SWAN'S ISLAND
CHRONICLES

SWAN'S ISLAND

CHRONICLES

BORROWED, EXAGGERATED

AND

HALF-FORGOTTEN TALES *of* ISLAND LIFE

Kate Webber

Charleston London

THE
History
PRESS

Published by The History Press
Charleston, SC 29403
www.historypress.net

First published 2014

Manufactured in the United States

ISBN 978.1.62619.317.8

Library of Congress CIP data applied for.

I love Swan's Island. I'll never leave, long as I can take care of myself. Why would I? I've got everything I want right here.

—Dorothy Stockbridge (1934–2013)

CONTENTS

CONTENTS

ACKNOWLEDGEMENTS

I can't possibly make a complete list of all the people who made Swan's Island feel like home to me: neighbors, knitters, historical volunteers, teachers, volleyball players, students, singers and coffee drinkers, to name a few.

A big thank-you to my lovely fellowship advisors, Gwen May and Bev McAloon. Your support, humor and insider information made all the difference. I'll miss our Tuesday morning meetings and all the fun we had in between.

My fellowship also wouldn't have been the same without my unofficial advisors, Candi Joyce and Donna Wiegle. Thanks for taking me under your wings when you had plenty under there already.

Thanks to the Swan's Island Historical Society for letting me run wild for a couple of years. You never said no, even when you probably knew better. The amount of knowledge and wonderful stories you have stored up are just incredible, as is the work you've been doing for decades to keep them alive. Particular thanks to Dexter Lee, who answered my fact-checking e-mails right up until the deadline.

Of course, I have to thank my fantastic island band, Noah's Ballast, for their hours of practice, our mutual efforts to overcome stage fright, all of their talent and the jokes that made the time fly by. Sonny Sprague, Don Carlson, John Follis, Vernon Johnson, Jud Cease and Dawn Neale—keep on playing! And I couldn't forget our two groupies, Dot Barnes and Marsha Douty, who arrived first at every show—often before some of the actual band members.

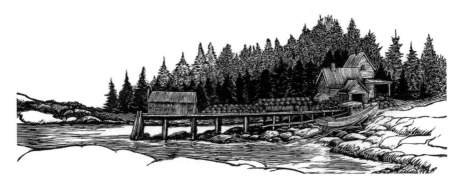

Axel's Wharf, by John Bischof. Axel Carlson's wharf in Minturn, with wooden traps and lobster boat. *From John Bischof, Swan's Island Educational Society Collection.*

None of this would have been possible without the Island Institute's work to support communities like Swan's Island. Its staff is one of the most dedicated groups of people I've known, and they sure do love their islands. Thank you to Chris Wolff and Karen Burns for your damage control and therapy skills. And thank you to my fellow fellows for commiserating over the unique nature of island life and providing social contact with people my own age every few months.

I'd also like to let my family know I'm glad they encouraged me to give this whole island thing a shot. Thank you for your support from afar and for absolutely everything.

INTRODUCTION

*After nourishment, shelter and companionship, stories are the thing
we need most in the world.*
—Philip Pullman

Swan's Island sits six miles off the coast of Mount Desert Island, Maine. The roughly 330 year-round residents primarily make their living on the water or providing services for those who do. A forty-minute ride to the mainland on the car ferry brings them to doctors' appointments, stores and other troublesome things. Apart from that, it's pretty much like anywhere else. Give or take a few things.

There are a lot of expectations about the nature of life on a Maine island. When I tell mainland people where I live, they don't say, "Oh my! How do you handle the night life?" or "Gosh, it must be tough deciding which shopping mall to go to!"

I think we all take a little pride in that—both in living up to the expectations and in defying them. Some things hold true to the stereotypes. We have nice views out here. There are lobsters. Winters are a little quiet. And, for better or worse, the moment you step off the boat, your personal anonymity is forfeited.

Trying to summarize the people of Swan's Island is a similar task to describing what Americans are like or what people in general are like—an exercise that's pointless, though often attempted. We have our socialites, dog enthusiasts, cooks, quiet people, teachers, Facebook users, recluses, partiers,

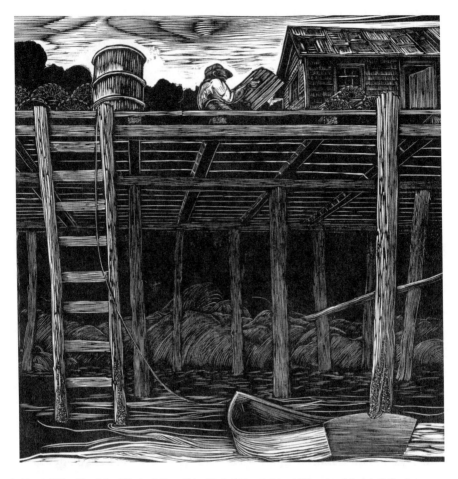

Joyce's Wharf, by John Bischof. *From John Bischof, Swan's Island Educational Society Collection.*

gardeners, teenagers, bikers, Christians, knitters, artists, ne'er-do-wells, parents, guitarists and a thousand other mix-and-match categories. You just get to know them a little better than you might in a larger place.

Life on a Maine island is about as exotic as your visit is short. Once you move in, you learn quickly enough that people are as nuts and wonderful here as they are anywhere. The single store with its limited hours sounds quaint and pleasant until you realize an hour before your dinner guests arrive that you need an egg and it's after 3:00 p.m. The isolation is romantic until wind conditions cancel the ferry on the day of your flight or job interview.

It's possible that Swan's Island attracts and keeps hold of a certain sort of person. Whether they were born here or came of their own free will, it shapes them. It encourages a certain way of life, certain values and a certain sense of humor. It is also true that everyone's out here for a reason. These are people who have chosen this home because something out here is worth the sacrifice of countless conveniences. Everyone has a reason to be here, and everyone has a story. Those stories are what lie at the heart of Swan's Island.

I came to the island in 2011, a farm country–raised stranger with New York plates and a shiny new degree from a Maine liberal arts college. I had been hired by the Island Institute to work for the Swan's Island Historical Society through the Island Fellows program. I never would have guessed how quickly this strange place would come to feel like home.

My work was a continuation of a project started by the previous Island Institute fellow, Meghan Vigeant, and the island's dedicated historical volunteers. They banded together after a fire in 2008 ate up the island library and historical collections. The tragedy inspired the islanders to save what remained of their history, much of which lived only in memory. Many hours and many islanders willing to share their family photo albums and stories resulted in an up-to-date, marvelously expanding historical collection. The new library opened in the summer of 2011, and the historical society's programming and volunteer force has never been more active.

My work included expanding the digital photograph collection, conducting oral history interviews, creating online content, working on service-learning projects with the island students, research, writing and volunteer training. The Island Institute also encourages community integration—the time you spend getting to know a place by stacking chairs after public events, frying eggs at an Odd Fellows breakfast, getting drafted into musical productions, building fairy houses with kids and playing with an island band. All the usual things.

The stories in this collection were originally written for a column in the *Working Waterfront*. I wanted to take advantage of, and pay tribute to, the wonderful resources provided by both the historical society and island life in general. The stories consist of a blend of my own experiences, the memories the community has shared with me and historical research. All three sources are subject to flaws, but I like to think that makes everything just a little more exciting.

In writing these stories, I hoped to give a little pizazz to the "back in *my* day" tales that have provoked eye rolling in many a wise youth. So many fascinating and hilarious things have happened on this small island, but like everything else, they drift away. If these stories make anyone say, "Oh, neat!"

and go about their daily business with a little more pride in their island heritage, then I'll be happy. If they make anyone say, "Well, that's not how it happened *at all*," then I apologize—I am "from away," after all. And if they make anyone say, "Hey, maybe I ought to visit that Swan's Island place," then do come, but please remember to say hello to everyone you pass and try not to bike slowly in front of them when they're driving to work.

This book is an open response to the (probably) well-intentioned island visitors who ask, "No, really—*how do you live out here?*" It is a thank you for all those two-fingered waves over steering wheels, the pure joy of Tuesday night knitting, getting shoveled out of my driveway by people just because they were passing by and saw I needed a hand, the island kids who (mostly) think I'm cool even though I like history, the traditional fart noises made during Monday night volleyball serves, my band mates who always let me pick our coordinated shirt color for concerts, the majesty of owning your own clam license and the thousand other things that have made this island my home. I hope this book does justice to all of the memories that went into its making.

I
ISLANDS, IT TURNS OUT, ARE CHARACTER MAGNETS

As a kid, I wanted to be normal. Anything that kept me away from this ideal—namely, my nuclear family—was a threat. Middle school can be rough. Kids learn that the more they act like everybody else, the easier life will be. It took me awhile to appreciate "characters," which as far as I could tell was a polite way of saying "embarrassing people." There were a lot of characters connected to our family: the feisty old ladies whose houses my Pop painted, the old school buddies he met in the cereal aisle and Joe, who would come bearing odd presents like Croghan bologna and talk for hours on our front porch, occasionally pouring a splash of beer on the pavement for the dog to lick up.

Little did I know I was receiving an education. The world is a wacky place, and the wackiest people can thrive like beautiful dandelions on the lawn. The characters I knew, many of whom have since passed away, were chock full of stories that only they could tell. That's part of why my time on Swan's Island has been so valuable; I'm allowed to—heck, paid to—interview people and catch all those fascinating glimpses into people's lives and struggles and loves. And who would have guessed it? Islands are magnets to characters.

We're stuck in the chicken and egg scenario. Does it take an odd person to want to live in the middle of the ocean? To voluntarily give up access to movie theaters, doctors and the widely acknowledged human right to purchase ice cream after 3:00 p.m.? Or does the experience of living out here make people different—give them the sense of humor and powers of resourcefulness that they need to survive?

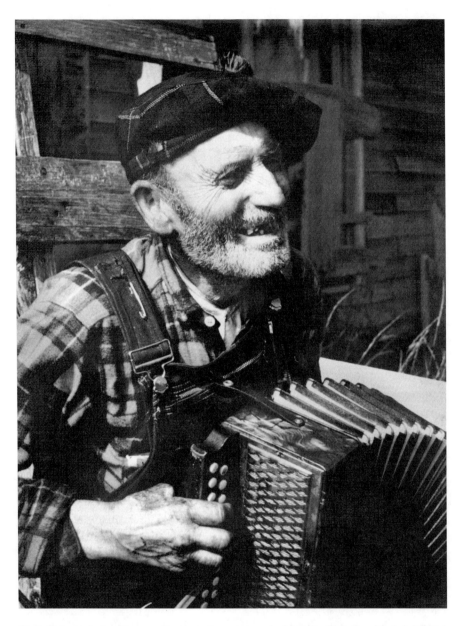

Clyde Torrey playing his accordion, wearing a cap and a big grin. *Photo from Marjorie Whitted, Donna Wiegle Collection.*

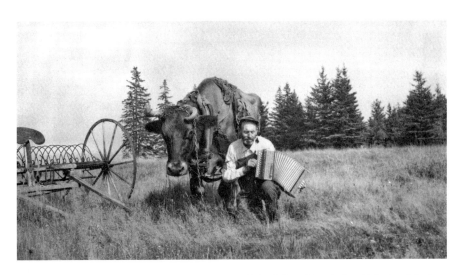

Clyde Torrey (1898–1974) playing his accordion to his bull, Boy. *From the Donald Carlson Collection.*

Clyde Torrey stands as the classic example of a Swan's Island character. In interview after interview, people tell Clyde stories when they want to explain what's special about island life. Folks would bring their visiting friends to see him like you would take a tourist to a local landmark.

Clyde was a self-educated man, a great entertainer and a lifelong bachelor. He was famous for his farming methods—namely hitching an ox and horse to pull the same rig. Clyde's accordion, rough singing and constant chewed-up cigar were trademarks. He put on "hootenannies" full of music, a little drinking and good fun.

Sonny Sprague spent a lot of time over at Clyde's in his younger days. "Everybody knew Clyde," he said. "A lot of people kinda laughed at Clyde. You know, he was an old hermit, more or less. In the wintertime, it was cold, and he lived in a car. Lot of things like that. He didn't have much, but he was Clyde.

"I remember when I went in the army," Sonny said. "We were playing baseball and someone said, 'Sonny, there's a big sign up on a telephone pole. I bet Clyde's got that sign up. Go look at it.' It was on the back of this old cracker box, said, 'Hootenanny Tonight in Honor of Sonny Sprague Going in the Army.' So Clyde was my friend."

It was tough to watch Clyde declining in his later years. The islanders gave him meals and a camp to live in, but he was sick. "He died," Sonny said. "He'd been away to the funeral parlor and all that, and they were bringing

him back on the ferry to be buried. They were bringing him home. I went to the ferryboat to meet the hearse.

"He always used to play the Blue Skirt Waltz," Sonny remembered. "And I never heard the Blue Skirt Waltz on the radio, never had heard it. So I'm driving to Atlantic, and I'm coming down by Andrew Smith's store, you know where I mean, that general area. There weren't so many trees there, and I could see the ferryboat coming round the point. And the Blue Skirt Waltz came playing out on the radio. It played as the boat was coming round the lighted bell. And I'll never forget it. Never."

Clyde was one of the few born islanders to have a "summer residence": a car jacked up on blocks where he sat listening to Red Sox games on the radio. One night following a dance, Clyde's house burned down. The community rose to his support, as Swan's Islanders do for those in need. Johnny Wheaton even gave Clyde the hat right off his head. A small building was moved to the property, though Clyde later relied almost exclusively on the car for housing.

Bill Coleman, a summer person, remembers visiting Clyde one time and seeing a second car next to the original. Clyde opened the trunk to get a book and calmly asked, "You haven't been over here since I moved to the Chevrolet, have you?"

Sonny summed him up pretty well: "Clyde always let you know what side of the toast to put the butter on." Every community has its characters, the odd folks with hearts of gold. Out here, they're appreciated in a way that only a small town can. There will always be conflicts and rivalries—some stretching back decades—but it's understood that you're allowed to be a little different. People know who you are.

2
LEGENDARY ANIMALS AND THEIR FANS

I think we can all agree that any story with pets in it has a chance of being five times better than a story without. They pee on things, make noises and get into predicaments in a way that has almost unlimited comedic potential.

In this age of global communication, what has transcended cultural boundaries? Cat videos. Perhaps we're living in a more cynical time, one that makes us question whether we really like humans all that much. But animals—boy, we sure like them! Own as many electronic devices as you like and watching a dog scoot across the lawn on his butt will still be just about the peak of entertainment.

During the process of my oral history interviews on the island, I never specifically set out to talk with people about animals. When talking to a person whose family struggled to scrape a living from the sea, I didn't want to be the bonehead asking, "So, didja have any pets?"

Turns out, I didn't need to ask. In interview after interview, animals appeared—whether surprising visitors from the wild or beloved fixtures of the household. It shouldn't have surprised me, given the prominence of pets on Swan's Island now. The island is pretty much dog heaven, with its beaches for running and swimming and rolling in dead things. Cats are also much loved, though they run into trouble with the local bald eagle population.

There is one prominent Swan's Island cat story that has almost no chance of being true, but I like it so much I'm sharing it here anyway. This story is related in a column from the *Island Advantages* newspaper that Gordon MacKay wrote in the mid-1900s. I would be interested to know where he got

his information—probably mostly through word of mouth, like I have. Use this as a cautionary tale, reader!

McKay's story revolves around the original owner and namesake of Swan's Island, Colonel James Swan, who gets the credit here for creating the Maine coon cat. "It all began with the Marquis de Lafayette," McKay writes. He pours forth a story with all the elements you could ask for: romance, plots, hidden notes and alcohol-based mistakes. According to the tale, Lafayette runs into Colonel Swan during the American Revolution and shows off the picture of Queen Marie Antoinette that he carries around to parties. Swan falls in love. McKay doesn't mention that at this point Swan has been married for fifteen years, but I guess that would take some of the romance out of it.

In 1792, Swan has a ship built and sends it to France to rescue the queen from danger during the French Revolution. Her household goods and furniture (including two cats!) are loaded on the ship a week before the lady herself is to come onboard—proving that Swan is a practical man even in the throes of love. The fact that the mission succeeded thus far is impressive, considering a massive unloading of goods from Versailles must have been somewhat conspicuous. According to the story, Swan's crew did not even speak French. McKay writes that Swan himself spoke only English, which seems unlikely given his education, connections and the fact that he would very shortly move to France permanently.

Two days before the ship sets sail, Swan sends two sailors to meet the queen with a vase of roses. The roses conceal a note detailing the departure plans. You know, because if you're trying to remain undetected on the streets of revolutionary France, you send the guys who speak only English with an armload of decorative flowers.

The sailors' route takes them past a wine shop. Its owner, Monsieur Defarge (also in Dickens's *Tale of Two Cities*), assumes that, what with all the roses and secrecy, they must be transporting a famous diamond necklace (as seen in history's "affair of the diamond necklace") to Marie Antoinette. Defarge decides to seize them for the sake of the revolutionary cause—and because, well, diamonds! He gets the sailors roaringly drunk and intercepts the bouquet.

After this mess, in October 1793, Marie Antoinette is guillotined. "A sad Colonel Swan returned home with two cats," McKay writes. The cats go to the mansion Swan built on his island "for his hoped-for guest." I'm sure the French queen would have just loved living on a Maine island with nothing but trees, wind and migrant laborers.

A little more digging reveals a possible source of McKay's story. When island historian H.W. Small published a volume on the history of Swan's Island, he included an article written by the "Saunterer" after picking up a favorite local legend in Wiscasset, Maine. The story details the exploits of a Captain Clough, who ran loads of lumber from Wiscasset to Paris during the French Revolution. In this version, it is Clough who decides to rescue Marie Antoinette and loads his vessel with her goods in preparation for escape. Colonel Swan's role is diminished, but he does appear:

> *The owner of the lumber trade in which Capt. Clough and other captains of this district were employed was one Col. Swan of Boston town. He seemed to have had a hand in the proposed rescue of the ill-starred queen, for at any rate, after the arrival of the bark* Sally *in 1794, and a declaration of failure of the rescue plan, Mrs. Swan built a fine mansion in Dorchester, and in it the astonished neighbors found such fine furnishings and draperies as they had never dreamed of. Not only were there many pieces of comfortable rich furniture, but there was one bed which Col. Swan's family always called the Marie Antoinette bed, and many beautiful court gowns, foreign to anything the natives of Boston had ever seen, were at times displayed for their admiration.*

And what is the conclusion of all this? Why, that the cats made Swan's Island their home and formed the breed we now know as Maine coon cats. And to hand some credit to McKay, it is true that the island's feral cat population includes many longhairs. They're not particularly majestic, but after all, it's been two hundred years.

Those of the island's current animals who can't boast of a royal lineage instead have to work for their keep. Several households have chickens and ducks, which means there are tasty eggs for sale during the laying season. Guinea fowl were introduced following a false rumor that they eat ticks. These beautiful, ridiculous birds add excitement to the lives of anyone driving through the Atlantic side of the island, since they have little to no respect for traffic laws. They also have a habit of ganging up outside the library doors and squawking during serious literary events.

There are a couple of families with sheep on the island—a popular livestock choice in island history. Some people used to keep sheep on the small barren islands off our coast, visiting them in the springtime to shear their wool. Sheep that are left to themselves to graze in the middle of the ocean do not have pleasant associations with humans, those two-legged

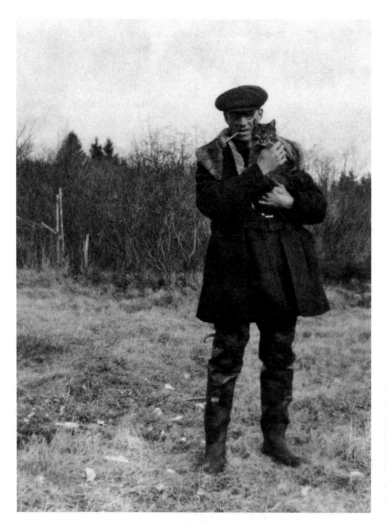

Merrill Joyce (1897–1976) smoking a pipe and holding a longhaired island cat. *From the Gwen May Collection.*

creatures that show up once a year to pin them down and remove their coats with sharp objects. From what I've heard, they put up quite a fight.

This trip was called "going sheeping" and involved community participation. The sheep owner would pack lunches and round up willing youngsters. Current islanders recall herding the mostly wild sheep with the special fondness that comes from looking back on things you'll never have to do again.

Carolyn Martin used to have a purely functional relationship with animals, but her opinions have changed with age. When she was six, she lived next to a turkey farm on the mainland. "It was just before we moved here, in fact,"

she told me. "And they hired us at fifty cents a bird to pick 'em. They taught us how to do it." When she got to the island, people brought her chickens to pluck. "Yes, they used to bring all kinds of things to me because I used to know how to cut beef and stuff," Carolyn explained. "Just coming from a farm, that was all. Didn't bother me any. But I couldn't think of plucking and eating them now."

I asked her what changed. "I just got softhearted," she said. "I love animals so. I just love every animal I see. If I had the money and I had the land, I'd have a menagerie. There wouldn't be any wild cats in the woods 'cause I'd catch them and take them in and feed them."

Donnie Staples had a similar experience. He's well known for his variety of livestock over the years, from sheep to miniature horses. "Earl Lowell and I were gonna raise cattle to butcher in the wintertime," he said. "So I went down to Machias and picked up two little calves. Donnie was the one that raised 'em," he chuckled. "When it come time to kill them, Donnie couldn't kill 'em."

He knows his animals aren't always practical, but they sure are nice to have around. "That's what happens when you get old like me, foolish," he laughed, talking about his miniature horses. "But I have a good time with 'em. 'Course, the mother, I've had her hooked up to a cart a couple times. And I hope this summer the weather gets good sometime, and I'll hook her up and go for a ride. The kids have a good time with 'em.

"One of 'em there is just like a buddy to me. He wants to be hugged every morning. Makes up faces at me and wants his carrot or apple, whatever I take down to him. It's a lot of fun, but it's a lot of work. My wife kinda blames me for getting all these animals so I wouldn't have to take a trip anywhere," he confessed.

Donnie's bull, Big Fella, was famous around the island. "I had a friend of mine from Nova Scotia that worked on a farm, and he was telling about big animals," Donnie said. "I told him, I said, 'I got a big animal, too.' He looked at me kinda funny. So he came up here one time to visit me. I took him down to show him Big Fella. Big Fella's out in the middle of the pasture, and he sees us. 'Course, he always come up to me running across the field.

"I mean, when you see him coming at you, it's kinda scary. That fella didn't know what he was gonna do. He got right behind me, scared to death of him. He said, 'Wow! He really is big.' I can't remember how many feet around him now, but we measured him one time. He must have weighed, oh, two thousand or more. He was big; I mean, he really was big."

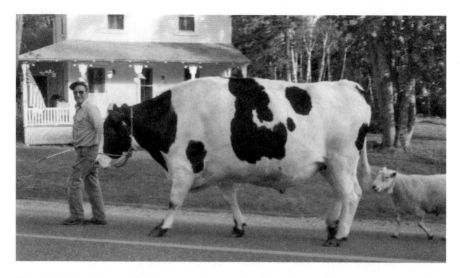

Donnie Staples taking a walk with his bull, Big Fella, and his sheep. *From the Gwen May Collection.*

Bonnie Holmes is another native islander and animal lover. When I interviewed her at her Freeport home, one of her two cats kept jumping on the table. She remembered her island pets fondly.

"We had a dog," she said, "And our dog liked to chase cars. And one day, my mother had this bright idea—she heard it from somebody or read it—that if you throw water at the dog, it will break him of the habit. So she got a bucket of water and waited for a car to come along.

"I forget who it was driving—I wish I remembered. Whoever it was, their window was down. Mom threw that bucket of water—missed the dog, got the driver! Oh my God. That was funny. But my mother, she laughed! Never broke the dog of chasing cars."

This might be a fishing community, but people certainly appreciate their mammals.

3

WINTER FUN ON AN ISLAND

There was a time when I assumed the only thing worse than a winter on a Maine island would be *two* winters on a Maine island. Isolation, biting winds, solo board games—I would be lucky if I made it out with my sanity. Having survived in comfort, I now know that I had no reason to worry. Winter brings out the survival spirit in people out here. Everyone makes darn sure they come up with things to keep themselves occupied, from Saturday morning coffee hour to Monday volleyball nights. The winter crowd out here is *fun*.

There are aspects of this season that we relish all the more because they're not shared with the summer crowds: the glowing turquoise of the ocean beyond snowy shores; bright stars on the silent, frigid nights; and the parts of the woods where the moss is green all year. It seems like Swan's Islanders have always known how to get by in winter, though it sometimes might have been a close call. It was a stretch for plenty of families who made their money in the warm months and had to make it last year round—not so different from fishing families today.

Carolyn Martin moved to the island as a young girl. Her parents' farm was failing, and they moved in hopes of finding a better way of life. The wage her father was promised didn't come through when they reached the island. "Daddy went clamming to feed us," Carolyn told me. "I remember that winter: clams, beans and biscuits. But it was food."

Before electricity and indoor plumbing, winters were a whole different story. "The outhouse was up behind the barn way across the field,"

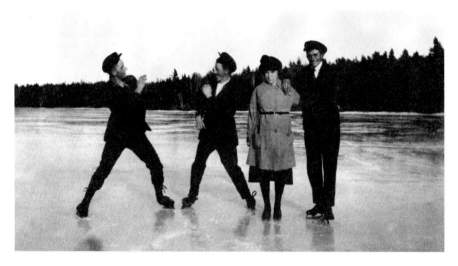

Young skaters on Goose Pond, Swan's Island, in the winter of 1924–25. *From the Marion Stinson Collection.*

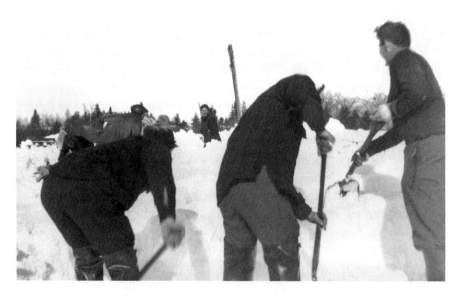

A hardworking crew shoveling the plow truck out of the snowdrift in front of Clyde Torrey's house in the winter of 1945. *From the Gwen May Collection.*

Carolyn said. "And it was nothing but a glare of ice. We'd have to walk out there in the middle of the night, and I ended up sliding down the road one night."

Kids came in to school early to gather wood for the stove (try talking a seventh grader into doing that now) and sometimes popped a potato in an empty coffee can to roast for lunch. There were plenty of reasons for a young person to look forward to the season. It was the time of year for skating, sledding, snowball fights and cranking homemade ice cream. When the harbor froze over, people would head out to meet or break loose the ferry—and before that, the steamboat. Walkers dragged a rowboat behind them as a safety net in case the ice cracked.

Clint Staples grew up on Swan's Island and spent more time in the snow than the average kid. His father, Bud Staples, was the island road commissioner. When a storm came, it was Bud's job to make sure the roads were cleared. "I never remember him ever being without a truck," Clint said. "And I never remember a time when I didn't help him with trucks—whether it would be helping him fix them or helping him load them if a snowstorm was coming."

Plowing is never easy, but back then they really had it rough. "I remember one storm, and this was probably in 1960 or 1961, I was probably ten or eleven years old," Clint said. "And there was a storm coming through. He was plowing snow at the time, and we didn't have any other way to load the truck except by hand. Had to load it full of sand to give it some weight and also spread the sand on the road after the storm went by to keep the ice off. But we'd come up to Mohler's pit just down beyond the Methodist church, and we would start shoveling, and we would shovel and we would shovel. For a young guy who had other things to do, it was not a fun day."

Of course, we're not talking about the nice big plows that scoot down the roads today. Clint's father just strapped a V-plow to the town truck. "It was a 1953 Dodge, not really big enough to handle a snow plow, but it did," Clint said. "Back then, the winters were much more harsh than they are now. And soon as the snow started to accumulate a little bit, he would get in the truck. It was the only one on the island, and he would keep the path open.

"His primary objective was to keep a path open from Georgie Tainter's house to the power plant down on the quarry wharf," Clint explained. "Because that had to operate. If the power plant was down, the island was without electricity. He would start out in that thing as soon as the snow started flying, and he wouldn't come home except for maybe a quick cup of coffee and a sandwich and go out again and keep going. The storms back

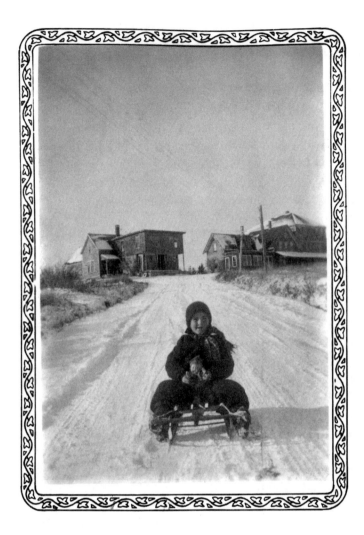

Donald LeMoine sledding on Steamboat Wharf Hill. *From the Christal Applin Collection.*

then would last a long time, accumulate a lot of snow, and he would just go for twenty-four hours or more sometimes just to keep the roads clear."

It wasn't just a matter of endurance but also bravery. Bud Staples knew trucks, but something could always go wrong. "One day, we were going down around City Point," Clint said. "The truck body was about halfway up—it was getting a little low on the sand in the back. There were some low telephone wires hanging over the road, and it caught the top of the truck body and dumped it vertical. It was straight up. I was in the back, and it threw the dirt out past me, and I managed to stay in back of the truck. Didn't get thrown out, but it scared my father to death. He pulled down two

telephone poles before he came to a stop, and one of them landed in the back of the truck right next to me. He thought he'd killed me. But there was no damage," Clint chuckled, "except my grandfather, who was co-owner of the island telephone company, was a little bit upset because now we had work to do to reset new poles."

The contrast between the seasons on Swan's Island was pretty shocking to a newcomer. It's hard to catch a breath in the summer months, with multiple events every weekend. There are even times when two things will happen on the same *night*! Suddenly, a ferry trip has to be booked weeks in advance to beat the crowds. In June, when the summer folks started rolling back in, I'd think, "Who are *they*? They don't even wave when you drive by!" Never mind the fact that some have been coming out for thirty years. This was my island! I'd survived the winter!

Winter creates a bond between people: chatting in the mailroom about the recent cold snap, sympathizing over the blizzard that canceled afternoon boats. A different community emerges—one that's less visible in the madcap days of summer. As the snowdrifts pile up, people talk longingly about stealing trips away south while everybody nods in agreement. A lot of it is just bluster. Where else would you rather be?

4

ONE-ROOM SCHOOLS, THEN AND NOW

Igrew up hearing stories of my grandmother's days in a one-room schoolhouse. She worked with one ear tuned in to catch the older students' lessons across the room. A few years ago, a local history group moved a tiny renovated schoolhouse, which spent part of its life as a chicken coop, to the field across from "The Farm"— grandma's central New York home. As a kid, I imagined her scribbling away inside walls like those, back when the world was black and white and everyone was friendly (as it turns out, my imagination was not 100 percent historically accurate). It wasn't until I came to work on a Maine island that I learned multi-age classrooms are by no means a thing of the past.

Swan's Island has a healthy school population of between thirty and fifty kids ranging from kindergarten to eighth grade. They're booted off elsewhere for high school. Many of those older kids make the brave daily commute on the 6:45 a.m. ferry to Mount Desert Island. As rough as this sounds to my fellow non-morning people, it's a convenience compared to the days before the ferry came. Students seeking a high school education would usually board on the mainland and come home for holidays or weekends if they were lucky. It was a dramatic change to go from a life within an insulated, close community—where your teachers know not just your name but also the names of all your relatives—to an anonymous boarding school environment.

The daily steamboat run once forged strong connections between Swan's Island and Rockland, so students often schooled there and boarded with

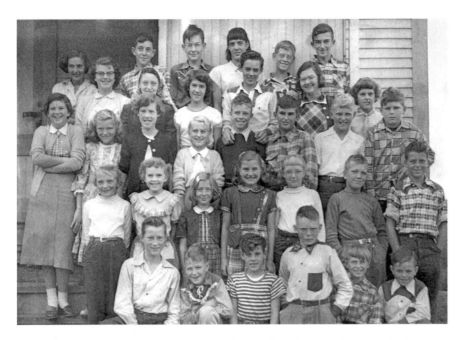

Grindle Hill (also known as Swan's Island Harbor) sixth through eighth grade class, 1951–52. *From the Christal Applin Collection.*

relatives or family friends. Post-steamboat students often went to boarding schools such as Higgins Classical Institute in Charleston, Maine. Some were eager for the chance to go to a new place, while others (understandably) spent time being violently homesick.

Even with today's relatively convenient ferry run, island students' experiences still differ from those of their mainland peers. There are three classes in the school: kindergarten through second, third through fifth, and sixth through eighth. The teachers have the challenge of teaching every subject to students at three different levels. Brave souls! The combined grades create a unique classroom environment that is compounded by the close ties among the students. When I asked the kids what they liked most about school, one responded that he was related to one-third of his classmates. It feels like a family.

Before consolidation in the early 1950s, there was a different school for each of the island communities: Minturn, Atlantic and the Harbor (also known as Swan's Island or "the Village"). There are stories of people's island-born parents not meeting until eighth grade graduation.

Plenty of islanders have fond memories of school shenanigans. Apparently, the fact that the teacher knows your family doesn't keep you from being a

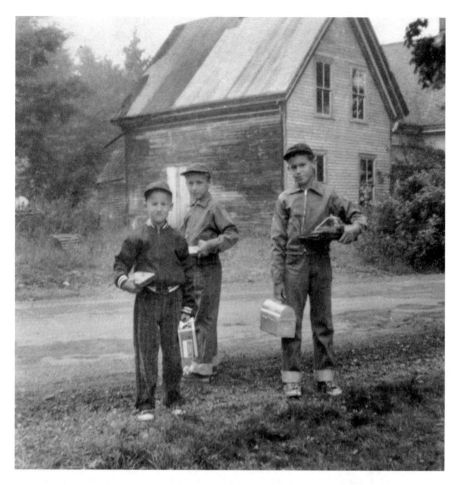

Timmy, Peter and Terry Staples in the 1950s, waiting with their lunch buckets for the school bus. *From the Marguerite Staples Collection.*

pain in the butt. Native islander Marion Stinson got in trouble a few times. "We went down in the cellar and smoked cigarettes," she confessed. "And the teacher come down and caught us. And they had all kinds of wood in there. 'Course, we threw the cigarettes, so they had to clean all the cellar out and get the wood out and make sure there was no fire."

Another day, the students decided they'd rather skate than sit in class. "There was a lily pond over in the middle of the island," Marion explained. "So, first one kid would go out to the bathroom—it was an outhouse connected to the school—and be gone quite a while. Well, that one never came back, so the teacher would send another one down to get that one.

Then another. Weren't ever in the bathroom at all—we snuck through the woods and went to the lily pond. We had our skates all hid. And finally, at the end of the day, there was nobody there to quit school. We was all gone to the pond to skating. We were devils, I must say we were!"

I got to experience school life firsthand through my historical work with the Swan's Island kids. I started up a "History Detectives" club that met after school at the library to learn about local history. Needless to say, it wasn't the coolest club a middle schooler could join—but island kids are forgiving. In the spring, we put together an exhibit based on an archaeological dig at the old quarry. My favorite student-made artifact identification card read, "Rusty Thing."

The next year, I tried to win points by using groovy new technology. I went into the classroom once a week to work on a multimedia storytelling program with the sixth through eighth graders as part of a service-learning project. Each student used iMovie to make a video clip telling a story about an aspect of island life, from lobster fishing to video games. I believe the community members appreciated the videos more than the kids did, but give them twenty years and they'll be banging at the library doors to watch the archived footage.

It was fascinating to see how tuned in those kids are to the community that surrounds them—something I barely thought of as a middle school student in a small town. Although the decades have breezed by, a lot of things have remained the same. Not all of the kids are native islanders, but there's certainly a sense of island pride in each one of them.

5

DR. HUNT BREAKS BREAD

Talking to the older island residents and summer people summons up a picture of the island's golden years—back when hordes of kids roamed around having adventures and life was packed with community events and neighborly good spirit. For some, this Swan's Island is gone. It's been worn away by the ferry's easy connection to the mainland and the now instant access provided by modern technology and entertainment. It's been lost with the generations of children who leave and change and don't return.

New faces come onto the island to stay for a day or year or the rest of their lives. They might become an active part of island life or they might decide to keep to themselves, depending on whether they're looking for a home or a vacation. The old Swan's Island wasn't familiar with that. People came out because they knew people or were looking for work or wanted to settle down with a family. Compared with that, today's Swan's Island might seem hollow to those who know it well. One man memorably called the current community "a gathering of strangers."

Of course, Swan's Island is not unique in this trend. The pain of change hits everyone who really loves a place and watches it through the years. My father has spent his entire life in his hometown and has seen the fields where he pastured cows and the woods where he walked and hunted gradually divided by house lots and No Trespassing signs. The conveniences of technology are small recompense; he would probably be happier without electricity, and he will certainly never approve of iPhones or jet skis. We all have our limits. I myself am a huge stickler for family traditions and

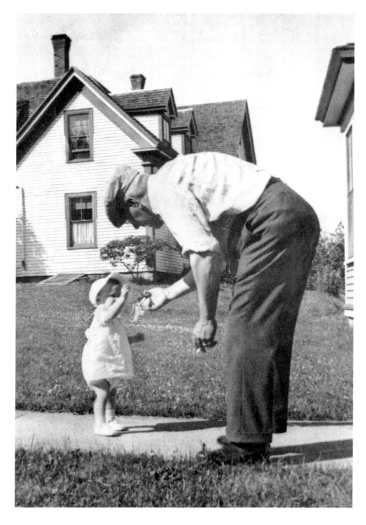

The generations meeting: James Sprague with his granddaughter Janis in July 1940. The house in the background belonged to Dr. Hunt. *From the Myron Sprague II Collection.*

therefore the biggest pain in the butt at holiday time ("But Thanksgiving has *always* happened this way! If it's different, it's not Thanksgiving!").

Personally, I take great comfort in the fact that people throughout history have consistently complained about everything going to hell. Around 23 BC, Horace delivered a "kids these days" rant about the degradation of Roman virtues (in translation):

What has not cankering Time made worse?
Viler than grandsires, sires beget
Ourselves, yet baser, soon to curse
The world with offspring baser yet.

If things were already going downhill before year one, I think we've managed pretty well for ourselves. It's just a matter of holding on to the positive change that accompanies the inevitable negative. I like indoor plumbing and constitutionally protected equality, and if that makes me a degraded youth, then so be it!

Along with the loss of the old community order, the island has seen some nice things happen. Most people don't have quite as tough a time of it as they did back in the day; they've got heat and food and a town that helps them if they don't. There are big-screen TVs, computers, fancy trucks and nice lobster boats that do a lot of your work for you. How many people would really go back?

Even bearing that in mind, it's hard not to regret some of those losses. The old way of life produced some fascinating people, the likes of which it's hard to imagine finding today. One such character is Dr. Harrison "Hal" Hunt (1878–1967), the most well-known doctor to have set up practice on Swan's Island.

Dr. Hunt accepted the post as Swan's Island's doctor in 1954 at age seventy-six, deciding it was time to take on a new adventure. In case this seems ambitious, Hal Hunt was no ordinary doctor. He was restless in retirement after thirty years as the chief of U.S. Public Health Services in his hometown of Bangor, Maine.

Perhaps more notably, from 1913 to 1917, Dr. Hunt served as surgeon on MacMillan's Crocker Land Expedition. The voyage aimed to do scientific studies while searching for a location Commander Robert Peary had seen from afar and dubbed "Crocker Land." Ultimately, MacMillan's expedition found that Crocker Land was simply an Arctic mirage. MacMillan and his team set up base camp in Etah, North Greenland, where they spent four years studying and exploring. They had planned on leaving after two years, but weather conditions made this impossible. The expedition couldn't be reached by ship in 1915, so they waited until 1917. Dr. Hunt and six Inuit were the first to bring news of the expedition to the outside world, having survived a four-month trip back from northern Greenland by dog sled.

Understandably, island life posed little challenge for the good doctor after that experience. He remained remarkably active and youthful into his

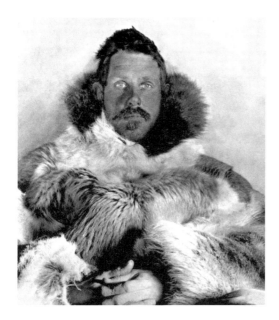

Portrait of Dr. Harrison J. Hunt by Donald B. MacMillan, colored glass lantern slide, circa 1913–17 (during the Crocker Land Expedition). *From the Peary-MacMillan Arctic Museum, Bowdoin College.*

eighties and introduced some Inuit practices that live on in island memory. His comfort with canoe travel baffled the local lobster fishermen, who worried about the dangers posed by currents, hidden ledges and bursts of wind. Dr. Hunt once used a canoe with an outboard motor to travel roughly twenty miles around the circumference of Swan's Island. Lobster boats radioed in reports of his progress until he safely reached the wharf.

After the Arctic, the doctor knew how to handle cold weather. Sonny Sprague remembers getting a sinus infection as a little boy during a vicious snowstorm. "We looked, and something's coming up the driveway, up by Annie Lunt's," he remembered. "It looked like an animal. It was Dr. Hunt with a musk ox hide over the top of him, coming up through the snow."

The doctor's methods were well suited for the island way of making do with what you have. "The cure wasn't to go off to Carroll's Drugstore," Sonny said. "He had my mother make a little bag and put salt in it and put it in the oven. She held it on my head, and a couple days later, everything came up and it was better." Although island memory has this as an "Eskimo cure," it's probable that it was a European practice picked up by the Inuit and later learned by Dr. Hunt. Salt wouldn't have traditionally been used in the Arctic.

Harrison Hunt made his mark on the summer people as well as the year-round residents. Fred and Lillian Pease have been spending their summers

here since 1957 and credit their most memorable welcome to the good doctor. "Our first arrival here was a classic," Fred told me as I sat in their living room in Swan's Island Village.

"Yes," Lillian agreed. "I was telling Angie today."

The Peases arrived with their two little boys, boxes, trunks and "Lord knows what else." They negotiated everything over several boat trips, saw it all up the hill and into their house and paused to catch their breath. "At that point, down the hill came Dr. Hunt," Fred said. "He must have been in his eighties. He just poked his head in and said, 'I'm not going to disturb you—I just want you to know I'll be down later to break bread with you.' And off he went."

Lillian chuckled and chimed in. "We thought, 'Oh my God, he's coming to dinner!'"

"We figured we'd just have to wait and see," Fred continued. "So we were trying to sort out the stuff we brought and put it someplace and whatnot, and toward the end of the afternoon, down the hill came Dr. Hunt. And he had a loaf of bread under his arm. He came in, and we greeted him, and he was able to sit on one of the boxes or cartons or something, and he reintroduced himself and we spoke for a little while.

"Then he said, 'Well, I won't prolong this. You've got a lot to do. This is an old Eskimo custom.' And so he opened the loaf of bread, the brand-new loaf of bread. He took out a slice, and he said, 'Do you have salt?' and we found the saltshaker. He sprinkled a little salt on the bread, and then he broke the bread into pieces and gave each of us a piece and took a piece himself, and we followed his lead and ate the bread. Then he said, 'This is a custom from the North. This means we are friends for life. And I won't bother you any longer.'"

"And he left," Lillian laughed. "Amazing." Although Dr. Hunt learned this practice in Greenland, it wouldn't have been an old Inuit custom; they had neither bread nor salt. However, the bread and salt welcome gesture is widespread among northern and eastern European peoples, most likely brought to Greenland by the Danes. It's fascinating to see a cultural habit from the early twentieth century Arctic surviving in the current memory of people on an island in Maine.

If we could talk to Hal Hunt, trapped in the Arctic in 1915, and ask if he would have chosen to live in a world of thermal underwear, GPS and helicopters, I wonder what he would have answered.

6
REMEMBERING RICHARD

The first day of spring arrived on Swan's Island about fourteen hours after a blizzard. I watched the snow blur outside my window, debating over the phone about whether knitting group ought to be canceled. It was. By now, spring has really sunk its claws in, with a few rain showers driving away all but the worst hunks of snow. Swan's Island is a place where the seasons make themselves felt.

You can live and work in a part of the world where you do pretty much the same thing in March as you would in August. In a fishing community, weather determines livelihood. Even to a transplanted landlubber with a desk job (that's me), the weather makes itself known. You can get stuck out here, and all of your wealth and charm won't make the ferry run. Weather is very democratic, and I think islanders secretly get a kick out of that. I know I did.

At this time of year, you feel the rumblings leading up to the island's busy season. Pretty soon, the ferry runs will increase, the calendar will get packed with events and the buildings that stood empty and pipe-drained all winter will fill with vacationers. And of course, the fishermen get moving.

Richard Kent was a well-known Swan's Island lobster dealer, oil deliveryman and probably a few other things besides. One afternoon last winter, I met up with Sonny Sprague, Donnie Staples and David Joyce to talk about their memories of Richard and their younger fishing days.

Their stories brought forth a man with a whole mess of interesting traits. They explained that he had his moments, but "he gave you the shirt off his

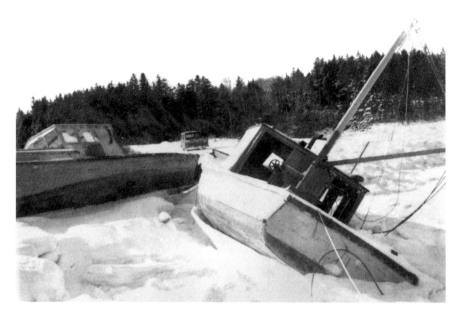

Richard Kent's boats waiting for the spring thaw on the bank in Mackerel Cove, Swan's Island. February 1965. *From the Gwen May Collection.*

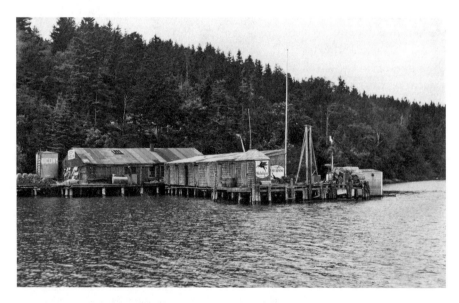

Frank Bridges's wharf in the late 1950s, which became Richard Kent's wharf. One building was a sawmill where they made lobster traps. *From the Lenora Wheaton Collection.*

back." Sonny worked for him as a kid in the summer and recalled the time Richard got mad and dumped a bucket of bait on someone. The victim watched in helpless dismay. "I can hear it now…'Lord, dear,' looking up at the sixty pounds of herring coming, pickle and all."

He was known to keep his old equipment right up until it gave out. David talked about Richard selling gas in the harbor. "I came in one day and didn't see any boat, but it looked like Richard was standing on the water. Well, the bow of the boat was above the water maybe an inch, and he was holding the gas hose out for me. He said, 'Well, we're still in business, old thing.' So I got my gasoline."

Sonny added, "When I worked there…jeez! He put Vern and I out on the oil truck, here we was, eighth graders. I remember backing up at Uncle Georgie's, George Smith's place. I wouldn't do it now—I'd be scared to death on that old junk. I can hear it now." Sonny rasped out some engine noises. "He'd bought a new rototiller, Uncle Georgie had, and I flattened it. Backed over it and put it right into the ground."

Part of Sonny's job was to keep Richard's boat clean, clearing out trash and coffee cups, but it didn't last long. "Richard could go down there—just like throwing a bunch of hens in," Sonny laughed.

David Joyce remembered the days when Richard Kent delivered oil to the island homes, always stopping in for a visit. "One time, he came to my parents' place," David said. "My brother James had this trap he was setting for squirrels. It was like a box that closes up when they hit the bait on a stick. That trap, I set it I don't know how many times. Never caught anything. My brother James went in the woods and set it; caught a squirrel first time.

"Brought it in the house, opened it up, 'Look what I caught!' Squirrel jumped out and starts climbing the windows. Just about that time, Richard came with oil, and he walked in the door and set down in a chair beside the door. The squirrel landed on his head! He didn't know what to do. Every time he came after that, he said, 'Well, how's the squirrel business today, old thing?'"

The stories reminded me of spring, with their life and goodness and mess. As my tires sink into the mud and green things start to pop, I'll think of Richard—who made a pet of a pheasant that followed his oil truck around the island. He was devastated when he backed over it. In memory of Richard and his pheasant, we celebrate spring and new life!

7

TRIPPING OVER HISTORY
EVERY DAY

One of the tougher aspects of being a newcomer to an island is keeping track of who people are. Decades of connections are at play. These facts are so obvious to everyone else that you feel like an idiot on a daily basis. My strategy after week two was to nod and pretend I had it all under control.

The person in charge of that group is so-and-so's mother? Ah, yes. I should interview your aunt's son-in-law? I'll get right on that. Then you just have to run off to ask a trusted confidant what on earth you agreed to do. I'm sure I've heard juicy gossip about someone and then chatted with him in the store the next day—with no clue that *he* was the one who did that thing that time. Basically, I can never say anything about anyone, which is probably for the best.

Newcomers also have a heck of a time getting around. I have yet to be given directions to any part of the island without the direction giver making reference to at least one person's house or some since-vanished landmark. The standard format is "Across from Dexter's," or "Over by Mertic's old airstrip."

It's an added bonus if the person is still alive, since place names often get stuck in an older generation. Solomon Barbour, an island inhabitant in the 1800s, is doubly remembered in Solomon's Cove and Barbour Beach. I'm in a better position than most; my historical work means I'm more likely to know who lived somewhere seventy years ago than who lives there now.

Confusing as it might be, I do love this aspect of island life. History is built into every day of the present. Walking on the shore of Cottle's Cove,

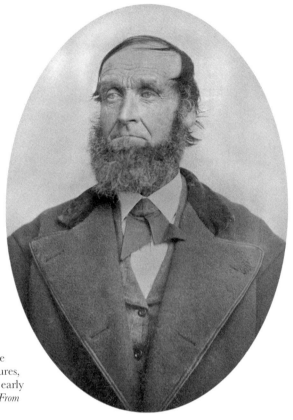

Tintype of Solomon Barbour, 1815–1896. Barbour, who gave his name to several island features, moved to Swan's Island in the early 1800s and worked as a baker. *From the Brad Ames Collection.*

you think back to the man who puttered around the islands on his traveling shoe repair barge until it finally beached for good. Mill Pond still bears the marks of an old industrial site, once the location of Colonel Swan's timber and gristmills. The footprint of Swan's mansion—known as "The Big House" in the years when new island families squatted there—is still visible as a rectangle of stone-bordered grass. It was supposedly built on almost the same design as Montpelier, the Knox mansion in Thomaston. Dead Man's Beach gets its exciting name from the story of a washed-up corpse. It was a nameless man in a suit with a few gold coins—respectfully left undisturbed—in his pocket.

Elsewhere along the shore, you find the black globules of tar left from the days before synthetic fishing rope. Carved wooden buoys live a second life as yard decorations. Walking through the woods, you see old quarry sites, house foundations and wells that have filled in over the years.

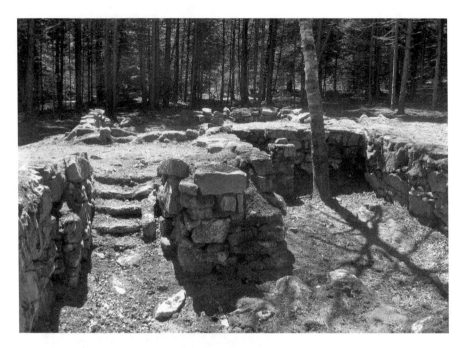

Building foundation remains at Irish Point.

There are many such remains in the area around Irish Point, named for the wave of workers who camped there to process timber in the late 1700s. Heading up from the beach, you see the footprint of the Idyll Wild, a hotel popular in the age of "rusticators" seeking nature and recreation. There's a little cemetery inland that holds the few early families who made their year-round homes on that harsh part of the island.

Island selectman Dexter Lee is widely known as a one-man repository of island history and lineage. "Well, I don't know," he said when I asked him to share some of his stories. "I think I have a good ear and can pick up stories and remember stuff around the island. They say I'm a pretty good historian. A lot of it is just listening to people talk and going through the old records. And everything I've found out about, probably somebody else could find out about it if I wasn't here."

But how many take the time? Dexter's stories are a representation of island life itself, with one merging seamlessly into another. A conversation about the Odd Fellows Hall leads to a discussion of its founders and moves on to their ties in the community. Dexter speaks about figures from the early 1900s like they were old friends.

"The biggest influence [on founding the Odd Fellows] might have been Herbert Joyce," he said. "He owned the sardine factory, had a store in Atlantic and then moved to the harbor and built the house that is now Ben and Belinda Doliber's. He had a wife, Durilla—they say she earned the money and he spent it." Dexter laughed. "He could spend money. And he always had big ideas. Supposedly, he had the first snowmobile, which was just a car with the front wheels taken off and skis put on the front."

Dexter knows all the dirt, like most genealogists—as long as you don't mind the dirt being a couple decades old. He doesn't reveal too much, though—such as in the case of one fisherman long ago who drowned off the coast. "Well, he drowned," Dexter said. "But he drowned with a hole in his head. I won't say who he was."

I've realized it's probably for the best that I don't know everything. Even if I wanted to, with only two years on Swan's Island, I don't stand a chance. I live in Johnny and Lenora Wheaton's place, and it will remain the Wheaton place long after I pack up and leave. Like Dexter, I'll just keep picking things up bit by bit—and, in the meantime, keep on nodding.

8

ISLAND ROMANCE IN THE DAYS OF PARTY LINES AND RECORD HOPS

As the days warm, the crocuses sprout, peepers peep and my lawn begins to fill with deer poop, it seems the season has finally changed. Earlier in April, the first tick of the year burrowed into my shin with cheerful tidings—don't worry, Mom, it wasn't on for thirty-six hours. I'll make it.

Ah, spring—when "a young man's fancy lightly turns to thoughts of love" (a sentence I'm sure many lobstermen find running through their heads constantly). I've always been intrigued by the idea of romance on the island—mostly because of the unexaggerated fact that you can't get away with *anything* out here. A co-worker visited the island last year. As I picked him up from the ferry terminal and drove past one islander after another (a process that requires waving if not direct eye contact on island roads), I thought, "Uh oh." The next day at a potluck dinner, people were asking about my "new fellah." They thought he had nice eyes.

So, I wondered, what must it be like for a teenager? Already the most troubled and misunderstood of nature's delicate creatures, how could they survive budding romance in a place without movie theaters, coffee shops or even the tiniest bowling alley? As much as I personally love the idea of having all my dates at the library, I can see how it'd be nice to have a few more options available.

What did couples *do*? I took the problem to my friends at the historical society, who had themselves survived this ordeal in the 1950s, '60s and '70s. I promised I wouldn't name names.

"Parking" was their first answer. An intelligent island teenager had a precise mental map of all the places that were not visible from the road or

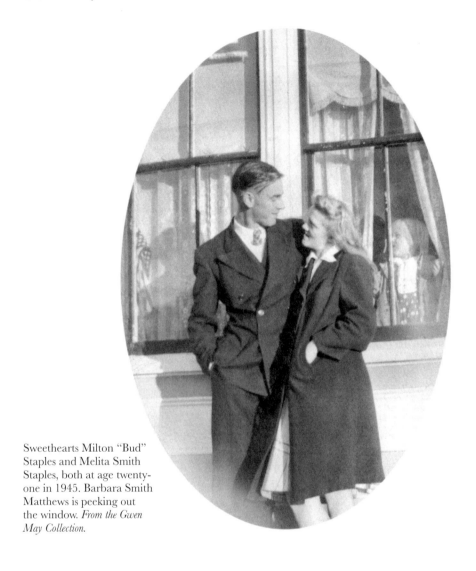

Sweethearts Milton "Bud" Staples and Melita Smith Staples, both at age twenty-one in 1945. Barbara Smith Matthews is peeking out the window. *From the Gwen May Collection.*

nearby houses. Cemeteries, the Quarry Pond, the area behind the Baptist church—I didn't press for too many examples, lest they suspect my motives. Apparently, the car was the center of both romantic and social activity. Kids just drove around enjoying themselves, whether with parental permission or partially terrified that they'd get caught.

"You had all the back roads," Donna Donley told me. "Nice hiding places when you were going out with your boyfriend. It was pretty hard to escape my dad, I'll tell you. I remember around nine, nine thirty at night, you'd be sitting in the driveway. He'd start switching the light on and off," she

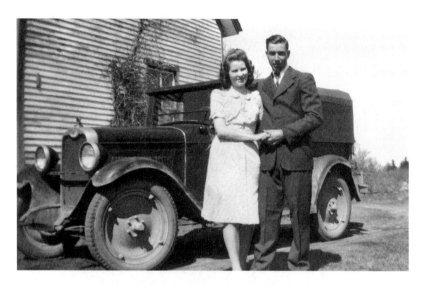

Newlyweds Eva Staples Wheaton and Burton Wheaton standing in front of Eva's parents' Model-A at their home in Atlantic Village, 1946. *From the Lenora Wheaton Collection.*

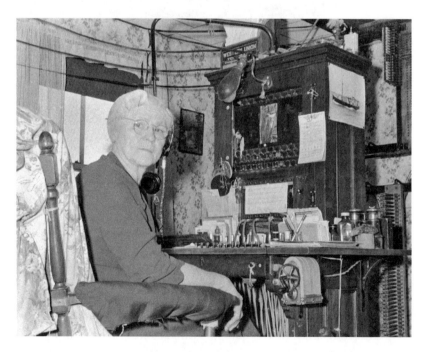

Lillian "Lil" Ash Smith (1885–1975) in the operator's seat at the switchboard for the Swan's Island telephone. Lil knew just about everything that was going on. *From the Marion Stinson Collection.*

laughed. "It's time to come in! Every night. My dad was pretty strict. I had a curfew. With five daughters, he kept on top of things."

I asked what it was like to grow up with four sisters, and she had mostly positive reviews. "It was good," Donna said. "They were my first playmates. Linda, Jean and I were all just one year apart, so we were very close, and I have to say to this day they're probably my best friends. And you know, you have your squabbles like everyone else, but it was a great experience, it really was. I'm so thankful I have them all. A little competition with the boyfriends," she laughed. "Jean would have one, and then I would take him or she left him and I would get him, and vice versa. I think every guy on the island, the three of us—Linda, Jean and I—were swapping around."

Today's couples have a great advantage in communication technology. A cellphone's privacy is remarkable compared to the old party lines on Swan's Island. These were the days when wiretapping was a local matter and a perfectly acceptable way to get your news.

A note to younger readers—a party line is not as exciting as it sounds. Several households would share one phone line, and a central operator (also on the island) handled calls between lines. Each home was distinguished by the number and cadence of rings: three long, two short, etc. Not only did you have to wait for other people to finish their calls before you made your own, but you also had the added excitement of knowing that anyone on your line—including the telephone operator—could be hanging on your every word. People reminisce about close-knit communities, but you have to wonder where to draw the line.

My informants explained that there usually weren't "dates." Young people traveled in groups: walking, swimming, skating and picnicking. You'd show up to an event and *hope* that so-and-so would be there. If they were, you'd steal some alone time and then head back to the group.

There was more dancing then—contra dances and record hops that Juanita Staples held each Wednesday and Saturday in a garage. Recreation opportunities have come and gone throughout the years as residents set up their own social events. They ran movie projectors, created a teen center and held ice cream socials, and for a while, there even was a bowling alley. As is typical of the Swan's Island spirit, people made do and made fun.

All of this nostalgia for the bygone days is not meant to imply that love does not blossom in the twenty-first century. My very first day on the island, a crowd of women surrounded me and debated the merits of a (limited) list of bachelors until I explained that, for the moment, I was out of the running. Unlike your average town, Swan's Island treats an unattached person as the

personal responsibility of every would-be matchmaker in the area. If you leave the island unwed, it won't be their fault for not trying. It was especially charming that this encounter didn't take place in a restaurant or living room but at the town dump. They mean business out here.

Many come here and fall for the beauty and romance of a Maine island, but I feel for those who fall for beauty and romance *on* a Maine island. I wish you luck and creative solutions!

9

LOBSTERING LINKS, PAST AND PRESENT

Confession time: I grew up five hours from the nearest ocean. Apart from a wonderful semester with the Williams Mystic program studying intertidal organisms, *Moby Dick* and coastal property disputes, I didn't know much about the sea. I certainly didn't know I'd be moving to the middle of it.

In my hometown, nobody thinks about the tide. One of the biggest dangers you face in Cazenovia Lake is scraping against a zebra mussel (to be fair, I still have a scar on my knee). I like to think that years spent honing my crayfish-catching techniques in an ankle-deep creek helped prepare me for life in a lobstering community. From what I can tell, the basic principle is the same: watch out for the pointy end.

On Swan's Island, it's a pretty safe bet that if you leave your house, you'll run into at least one lobster fisherman. They're the ones playing volleyball and chatting in the dump line and picking up their kids after school. There are limited job options for our 330 (give or take) year-rounders, so most men and many women spend their days working on and around the water.

My introduction to lobstering came through music. Two of my island band mates—Vernon Johnson (banjo) and Sonny Sprague (fiddle, vocals)—are longtime fishermen. During rehearsals, I got a sense of what the day-to-day life was like—tired evenings, good or bad hauls, watching the price per pound. Sonny's taken me out on his boat a few times—enough for me to see I'm not cut out for the job. Waking up before dawn is okay once or twice a year, but five days a week? No thanks. On a nice summer morning, it's worth it just to

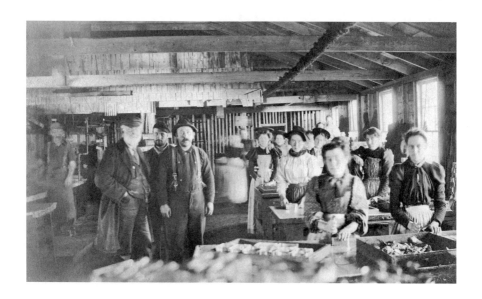

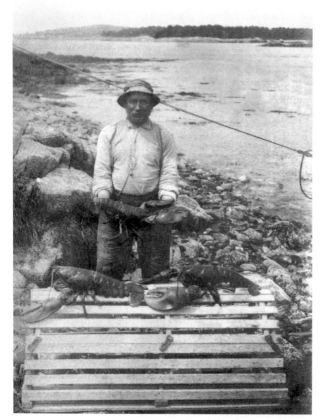

Above: Swan's Island fish factory workers between 1895 and 1900. *From the Gwen May Collection.*

Left: A Swan's Island fisherman holding a lobster by a wooden trap. *From the Norman Burns Collection.*

see the sunrise stretching out across the water. In the rain and bitter cold, you need more than a view to keep you going.

Sonny's sternman, Wayne LeMoine, showed me how to stuff bait pockets and put rubber bands on the claws. He made sure I saw every cool thing that came up in the traps, like a hermit crab I swear was as big as my head. I'll just take a moment to describe a fishing day for the benefit of my fellow landlubbers.

Fashion wise, we're talking multiple layers of clothing, the top three of which will end up smelling like dead fish forever. The outermost layer should be waterproof. The brand of choice is Grundens, a company that makes rubbery overalls that you step into and buckle over your shoulders, as well as an apron-like covering that I've heard affectionately called a "Grundens dress." You can accessorize with baseball hats and gloves.

Things start out great. I mentioned the sunrise. You take your boat out of the harbor, waving to any boats you pass. The radar system shows you where to find the traps you previously set, so you just aim for the little colored dot and let 'er rip. As you're bearing down on a trap, you aim for the buoy floating on the surface, which needs to be grabbed with a hook as you pass. The rope on the buoy is fed into the hauler—a spinning wheel that pulls the trap up out of the water. You grab the traps when they come up and swing them onto the side of the boat.

This is my absolute favorite part because you never know what the heck will be in there. Crabs, fish, a few lobsters, lots of lobsters—it's very exciting. Lots of lobsters can be misleading, however. It's quite a letdown to see eight out of the ten lobsters in the trap get flung over the side (probably a pretty thrilling moment for the lobsters, though) because they're too small or have notched tails. The v-notch means a lobster is a "breeder"; when you find an egg-bearing female, you clip a flipper as a way of marking her so she'll live to breed again.

The acceptable lobsters get rubber bands on their claws. Once you've done this to thirty lobsters, you will never be afraid to put them in a cook pot again. They're piled in crates with slots in the side. To keep them fresh and happy, or as happy as you could expect, you run pipes over the top to spray seawater on them. The nicer you treat them, the better the product.

As the unskilled member of our fishing team, my main job was stuffing bait pockets. Bait pockets are little netted bags that hang in the traps attracting lobsters. Sonny's boat has a huge blue barrel that gets pumped full of dead fish in a salty slurry. I got to grab big handfuls of mostly whole fish and stuff them into the bags for Wayne to attach to the traps before pushing them back over the side.

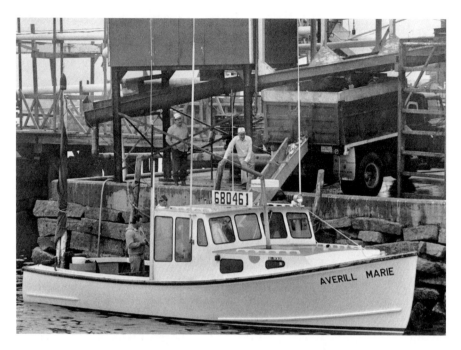

Normie Burns and his crew loading fifty bushels of bait onto his lobster boat at the Stonington factory in the late 1980s. *From the Norman Burns Collection.*

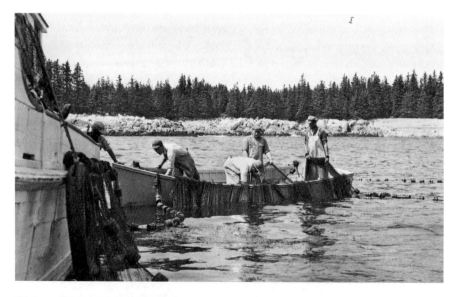

Seining at Frenchboro's Southern Cove, circa 1940. Two of the men are Cecil Lunt and Ralph Stanley. *From the Lenora Wheaton Collection.*

You'd think the handfuls of fish with their little eyes and unique smell would be the bad part, but you'd be wrong. What *really* gets you is the state of these guys after hanging around, decomposing and getting nibbled on at the bottom of the ocean for a few days. You have to empty out the old bait pocket before you can reload it with comparatively beautiful fresh dead fish. There's a whole mess of skeletons and miscellaneous fish bits that the seagulls go nuts for.

So here we are at about one o'clock in the afternoon—which seems pretty late in the day when you get a six o'clock start (later than many boats head out). The sun is really beating down now, and the boat is traveling in tiny circle after tiny circle to snag the buoys. You're elbow deep in fish juice, and each time an old bait bag gets emptied over the side of the boat, you get a brief whiff of something reminiscent of a decomposing animal passing gas.

I don't ordinarily get seasick, but these are not ordinary circumstances. I have nothing but respect for the men and women who make their living this way—I say lobsters should be worth their weight in gold. And I was only out on pleasant calm days. I can't imagine the folks who keep at it late into the fall, following the lobsters out to deeper, rougher waters as the mornings get icy and dark.

Some people love it and can't imagine doing anything else. Some people hate it but can't imagine doing anything else. Whatever the individual motivations, lobstering has shaped Swan's Island. You see signs of it everywhere—from the lobster trap Christmas tree on the side of the road to the fact that all community events start by 6:00 p.m. to accommodate early bedtimes.

Lobster fishing hasn't always been the main industry on Swan's. Prior to 1800, cod and haddock were the only profitable catches. Then mackerel became king. Vessels headed to southern waters in early spring and returned around the first of July to fish closer to home. Swan's Island fishermen were famous for their success along the Atlantic coast, taking first or second place in their catch every year from 1874 to 1889. By 1900, mackerel had been fished out. The island had a lobster cannery—later converted to clams—a sardine factory and a cod liver oil plant. The Depression and World War II emptied much of the island. Those who remained could at least depend on the ocean to feed their families.

In more recent memory, islanders have seined for herring, built weirs and caught smelt and even sea urchins. Swan's Island fishermen have actively protected their industry, voluntarily enforcing a lobster trap limit in 1984 and setting boundaries in response to a scallop boom in the late '60s that brought flocks of draggers threatening the lobster grounds.

Today's lobstering doesn't rely on rowed boats, carved buoys, wooden traps, tarred hemp rope or hand-knitted bait pockets. Machines help steer and haul, and radios connect boats. Sonny says a monkey could go fishing, but he's selling himself short. It's a complicated industry that has developed over generations. Fishermen experiment with location, timing, bait and even trap color. Some love it and some hate it, but it's wired into them.

When I hear the motors in the harbor at the crack of dawn, I'm amazed by this unique community. And then I fall back asleep.

CHANGING TIMES, CHANGING LANDSCAPES

I got thinking about changing landscapes after a night spent going over old photos. Kevin Johnson of Searsport's Penobscot Marine Museum came out to share glass slides of Swan's Island made between the 1910s and the 1940s. The Eastern Illustrating and Publishing Company traveled through rural New England and New York, capturing local landmarks and scenes for its postcard collection.

We had a grand old time debating over what was owned by whom and when. We oohed and aahed over the wooden sidewalks (fancy!) and the impressive masted ships in the harbor. The lack of trees changed everything; islanders cleared out the shore, building homes and boats and burning wood for heat. Without the familiar pines present today, buildings seemed taller and landmasses seemed shorter. It really messed us up a few times.

As a result of all this, I gained a new appreciation for my neighbor's house. The Chetwynds own what once was known as the Ocean View Hotel. Their current home is recognizable as a portion of the original large building. The Ocean View seemed like an obvious enough name since the front of the house shares the view of the harbor that I see from my kitchen window. After seeing the photograph taken from the tree-free back of the hotel, I realized they originally had an ocean view on *both* sides.

The hotel was first built and run by Cap'n Bill (Captain William Herrick, 1841–1925), a "masterful old sea-dog." In addition to the hotel, he owned a string of mackerel fishing vessels and a fine mustache. An anonymous clipping written around 1921 describes his retirement from the hotel business, during

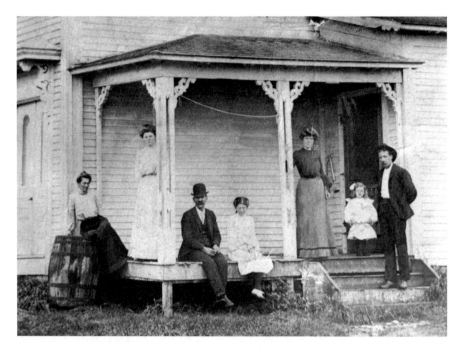

The Stinson family on the porch of their home, 1904. This house on Harbor Road looks about the same today. *From the Gwen May Collection.*

which time he still managed to catch a seven-foot, eleven-inch halibut. The article called it "the largest halibut ever caught at Swan's Island, which is as you probably know, the largest fishing hamlet on the Maine coast"—a little island pride for you.

Cap'n Bill was succeeded by his son Charles, of whom it was said, "He had a rocking chair permanently attached to his butt." He must not have lasted long because Lilla Moulden bought the hotel soon afterward. She lived there with Ray Stinson, who was a selectman for many years. Lilla fixed the building up, took in guests, did washing and ran a pie and ice cream shop. During this period, there were dances at the hotel that raised money for the first island fire truck.

Marion Stinson told me about the hotel in her day: "Mom took me to one [dance] over to Lilla Moulden's, and I raised heck I guess—she never took me again." Marion laughed. "She used to take my brother; of course, he'd fall asleep on the settees and that was fine, but not me, boy! I was right up and at 'em!"

The Stonington High School band would come once a year. "They'd play their instruments and everything. And you could hear them coming on the

steamboat. It would be so calm and nice, you know. And they'd play all the way in the harbor."

People who lived in other parts of the island would sometimes stay at the hotel before catching the steamboat out in the morning. Business slowed during the Depression, and the hotel joined many island industries in closing. I realize my finances couldn't handle a pie and ice cream shop within seventy yards of the house, but I have to say it's an appealing idea.

II

BOATS AND ISLANDS
GO TOGETHER LIKE...ISLANDS
AND BOATS

It seems to be a pretty well-known fact of island life that boats are involved. My own boat knowledge would fit in an undersized peanut, but you pick up a few things by hanging around. One secret to boat travel is to act casual, no matter how much they're tipping toward the water.

There's a joke I've heard out here about the tourist who looks at the lobster fleet moored in the harbor and asks, "Say, how'd they get all their boats pointing the same direction?" I've personally decided that it's probably something to do with the winds or tides or seagull poop or whatever. Now that I know it's a joke, I can never ask for a real answer and therefore can't pass on the knowledge to this readership. I guess the secret will just die out with everyone who's ever spent any time on any coast.

So, within recent-ish memory, the island fishing fleet has changed. Man- and wind-powered vessels are pretty much gone, sloops and seiners and draggers (I hope those are all real things) are pretty much gone and now we've got a uniform bunch of motor-powered lobster boats in the harbor. They appear different to the trained eye—all I can do is distinguish the one painted blue from the other with the funny name.

Swan's Islanders once constructed their own boats, from the large-scale boat-building shop on Johnson's Island to individual fishermen teaching themselves to make their own vessels. One memorable example is Wesley Staples I building a boat in a living room. His son, Wesley Staples II, remembers the scene: "Long before our house was finished, when we were

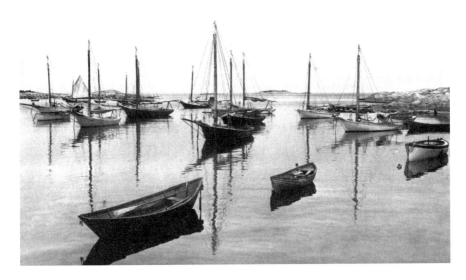

A calm sea in Swan's Island Harbor. *From the Gwen May Collection.*

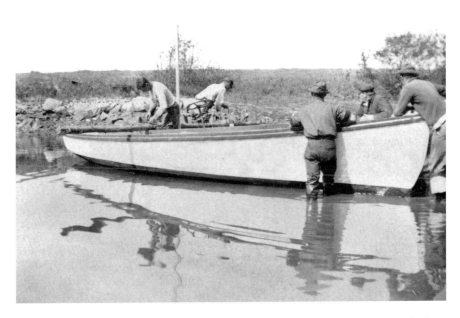

Men working on a boat. The two men in the stern are probably tying a pole perpendicular to the keel to steady the boat during launching. *From the Gwen May Collection.*

living in the den in the kitchen, my dad and his brother, Bud, built a boat in what is now the living room of that house."

Wesley Staples I was one of the islanders who mastered the art of making do—a great asset to island life. "He was extremely talented, my dad," Wesley said, remembering the work his father did on their family home. "He did not only the woodworking and the plumbing and electric, but he built the bannisters for the stairs, the furniture, the tables, the chairs and the lamps. He built everything. Necessity is the mother of invention. And my dad was certainly an inventor."

Part of the change in the construction of island boats started with the arrival of the Colemans in 1957. Bill and Billie (William and Mildred) began to spend their summers here and became part of the community. The Colemans were the first to bring fiberglass to Swan's Island.

Bill explained how it all came about. "When we arrived, all of the boats were wooden boats. We had started a company to weave fiberglass fabrics. I always had quite a bit of our products here, and I thought some of these fishermen would want some of these products for their boats. I was absolutely wrong," he laughed. "They wanted it, but they wanted it to fix their rusting-out pickup trucks. Some years later, they began to get fiberglass boats."

At the time, the island was chock full of disintegrating cars held together by luck, haywire and repairman Georgie Tainter. Word spread about the fiberglass, and Bill found himself in great demand. "I'm on vacation," he laughed. "I'm gettin' sick of this!"

And so the Colemans spread the word—anyone who wanted his car fixed could bring it over the following Wednesday, to get the repair work all over with at once. Bill remembers it well: "Five thirty in the morning Billie looked out the window and said, 'Have you seen what's going on out here?' We looked out, and there were the trucks lined up from Dick Reynold's house all the way up past the store, waiting. So we got out and went to work on all of 'em."

The day passed and then night. They strung lights up on the tree out front "so they could see to do it," Billie said. "It was really funny." Dick Holmes, part of the ferry crew, later told Bill that his marriage was saved that day. The fiberglass kept his wife's feet dry when he drove his truck through puddles.

The Colemans also built a distinctive fiberglass-molded cabin in the early 1960s. Its strength was tested over its first winter; local kids threw rocks on the roof to see if it would break. Bill and Billie returned the next summer to a mysterious stone pile on an intact roof. The island must have decided it was safe, since the fishing fleet began to convert.

Sheldon Carlson on his fiberglass lobster boat with his wooden traps. *From the Elizabeth Mills Collection.*

"The first fellow that had a fiberglass lobster boat was Sheldon Carlson," Billie said. "And that was a successful boat. He fished it for many, many, many years. All the rest of his life, he used that boat." As it turns out, it's still being fished today by Les Ranquist's daughters. The Colemans were delighted to hear that.

"Well, there was a time twenty years ago," Bill remembered, "that would make it, let's see…middle '80s and early '90s…when probably two-thirds of the fiberglass boats in this harbor were made out of our fiberglass. Then shortly after that we sold the company, and I retired. So after that, they weren't made out of our glass anymore."

But the "glass" boats remain. Maybe someday the historical society will look back wistfully at photos of fiberglass boats.

THE DASHING COLONEL SWAN

I figure it's time to set the record straight—Swan's Island has no connection with elegant white birds. Its namesake was Colonel James Swan (1754–1830), a brilliant, daring, morally questionable kind of guy. He was just as romantic and swashbuckling as an island's namesake ought to be—though you wouldn't necessarily want to be the island dependent on him.

A thorough account of Swan's life is provided by island doctor Herman W. Small in his 1898 book, *History of an Island*. He did extensive research into official records, as well as an account of the Swan family that a relative provided in 1894. Here's the lowdown:

James Swan was just a kid when he emigrated from Fifeshire, Scotland, to Boston around 1765. He first worked as a clerk and apprentice, and by age eighteen, he had educated himself to the point of publishing his first book. The book was about the African slave trade, discussing the evils of slavery before Americans were really worried about that. The abolitionist movement in the United States took place from the 1830s to 1870. Swan wrote in 1772.

As things started to heat up in the new country, Swan was right where the action was. He became a Son of Liberty and joined in on the Boston Tea Party. War broke out in 1775. He was wounded twice at Bunker Hill and was promoted to captain. Swan quickly rose in rank and honor, holding several key positions and using his own money to help the Continental army. He worked closely with Lafayette, Washington and his old pal Henry Knox.

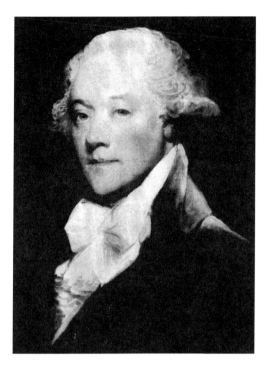

A 1795 Gilbert Stuart portrait of Colonel James Swan. *From the Edward Wheaton Collection.*

In 1776, Swan married Hepzebah Clarke, daughter of a Boston merchant and shipowner. The account provided by Colonel Swan's young relative didn't explicitly state that the marriage was a strategic career move, but it did say that Swan might have convinced a friend of the Clarke family to leave Hepzebah the entirety of the family fortune, neglecting her brother.

Swan began his pattern of brilliant-if-somewhat-shady business deals through land speculation. By the start of the Revolution, he is believed to have owned two and a half million acres of land. He purchased several privateers (private vessels commissioned in wartime to seize enemy ships) and bought and sold confiscated Tory property. Patriotic *and* profitable! He increased his fortune through a combination of smart investing skills and personal charm of the variety that makes new friends will their estates to you. Colonel Swan started living it up in all the usual ways: loose spending, duels and riding around in what he claimed was *the* fanciest carriage in North America.

In 1786, Swan bought Burnt Coat Island (now Swan's Island) and surrounding islands from the State of Massachusetts for £18,000. This was before Maine became a separate state. He brought laborers out to cut trees, work mills and generally make him money. One of the earliest batches of laborers was a group of Irishmen for whom a peninsula still bears the name Irish Point. Current islanders can attest that it's one of the roughest parts of the island to live on year round, and one can imagine these early workers weren't really enjoying an idyllic island experience.

According to Massachusetts law, the state wouldn't charge taxes if Swan brought twenty-two Protestant families out to settle the land. People came. Many had been soldiers in the Revolution and sought new opportunity

working in the mills, harvesting timber and fishing. Unfortunately, after the colonel built his sawmill and gristmill, he decided it wasn't worth it to build the school, homes and church that were also legal requirements. He thereby established the island tradition of doing things your own way, everything else be damned. And he did at least build himself a nice mansion.

Even so, Swan's investment never really paid off. In 1787, some of his speculations went bad and sent him deeply into debt. Hounded by creditors, he traveled to France incognito—something we've all wanted to do. Revolution broke out in 1789 and gave him a chance for a fresh start.

Swan made a business of helping French nobility move to safety in America. He loaded up his ships with their stylish furniture and expensive goods but sometimes failed to get the actual people onboard before they were guillotined. (Whoops!) The furniture is said to have ended up with Mrs. Swan in Boston, as well as in Henry Knox's mansion in Thomaston, Maine.

The colonel became an agent of the French government and bought goods from America to smuggle through the British blockade. He temporarily returned to the United States on this secret mission and negotiated the settlement of the American debt to France. He then lost his position in 1796 after being accused of misconduct.

In 1808, Swan was sent to the prison of Ste. Pélagie in Paris for a debt that he had the resources to settle. He refused to pay on principle, saying the claim was unjust. He stuck to that story throughout his twenty-two years in prison. According to Dr. Small, he seems to have lived pleasantly there. Prison life showed a gentler side of his nature:

> *He lived in a little cell in the prison, and was treated with great respect by the other prisoners, they putting aside their little furnaces on which they cooked their food, that he might have more room for exercise. Not a day passed without some kind act on his part, and he was known to have been cause of the liberation of many poor debtors.*

Swan's wife, Hepzebah, who was apparently just doing her own thing in America for a couple decades, sent him money to fund his comfortable imprisonment. Swan was even able to pay for apartments across from the prison, which he fitted with elaborate furnishings and servants to host visiting friends. Though he was stuck in jail, he paid for their carriage rides, trips to the theater and dinner parties—always leaving one open seat at the table in his memory. Poetic, isn't it?

A revolutionary decree released Swan in 1830 at age seventy-six. After over two decades in jail, Dr. Small explains, the colonel was unwilling to leave:

Scrag Island, by John Bischof. *From John Bischof, Swan's Island Educational Society Collection.*

Three days later, July 31, he returned to St. Pélagie to reinstate himself a prisoner, for what could this old man do, who had passed nearly a third of his life in prison? He found his former friends missing, his wife was dead, and conditions had all changed. His long confinement had robbed him of any desire to enter again the world outside, which was strange to him. His health was broken and his fortune gone.

Swan's one wish was to embrace his old friend Lafayette, which he accomplished. He died the next morning on the steps of the Rue d'Echiquier.

Needless to say, Swan's Island wasn't at the top of this man's list of priorities. Swan never even saw his mansion (known as "The Big House" to islanders) completed. He left for France during its construction and did not return to Swan's Island. His agent, Joseph Prince, lived on Harbor Island and looked after things until 1800, at which point the settlers were largely left to fend for themselves. New settlers squatted in the mansion until they built homes of their own. They divided up the land and formed their own way of conducting business without official interference.

In 1834, the pioneer settlement sought self-government. The nearly two hundred residents organized into the Plantation of Swan's Island, with elected positions, taxes, a school and roads. Years later, they became a town in the state of Maine. The rest, as they say, is history.

So here's to Colonel Swan, with a character about the exact opposite of the spirit that has developed on his island namesake. He was aristocratic, devious and extravagant—a far cry from the image of the rugged, honest Maine fisherman. Both, however, lived generously and never shrank from hard work—provided they could do things their own way. And both make for a great story.

13

THE SUMMER PEOPLE

"It's Different Now"

Looking out at the budding leaves and the boats in the harbor (sorry, couldn't help rubbing it in), it seems that the May air has carried in a hint of summer. Sue Wheaton tackled my lawn a couple days ago, shaking her weed whacker in the air and warning me to stay out of her way.

Like many coastal Maine communities, Swan's Island transforms in the warmer months. Ferry lines lengthen, beaches fill and out-of-state license plates make my own New York car blend in a little. There are as many island opinions on this phenomenon as there are islanders—some hate the crowds and fuss, some love the excitement and seeing old and new friends and some are just too busy working to care.

There's a long tradition of summer people out here, though the nature of vacationing has shifted. Originally, people didn't drive way the heck up here to rent a place for a week or so. If you came out, it was for the long haul. Teachers and preachers had summers free, and their families made up the bulk of the early summer residents. Since they were around for months at a time and Swan's Island isn't exactly packed with theme parks and all-night discos, these families fell into the swing of island living. They went to potlucks and church events, their kids made local friends and, all in all, they just became part of the community.

It's a little different now, since people just plain don't have enough time to become an active part of things. If you've got only a one- or two-week vacation, how can you form the same connections? There are plenty of exceptions, including the longtime summer people who have retired to make

The Lee family having fun on Swan's Island in the 1930s. *From the Sally Lee Collection.*

their year-round homes here. There's no doubt that seasonal residents have made and continue to make many contributions to Swan's Island.

In the early 1900s, the Lees and the Boones came to Swan's Island from Maryland. Their descendants have been spending summers here ever since. According to Sally Lee, a third-generation summer person, they had some memorable times. They entertained themselves with boating and cocktail parties—what must have seemed an outlandish pastime on an island that still forbids the sale of alcohol.

Sally told me about her father, Tyson Lee, and godfather, Teen Boone, coming home late from a party on the mainland. They made it into a weir and somehow sank the boat. She heard screaming. "I was probably five or six or something. I remember my mother getting a flashlight and running down. And she told me when she got outside, there was my godfather, in a dinghy, in a tuxedo, rowing into shore. And all he said to her was, 'Save Tyson.'" Sally laughed at the memory. "Stuff like that was not always happening, but you know, pretty regularly happening.

"The Boones and the Lees were all Catholics," she said, "and in the old days, if you were Catholic and there was no Catholic church, well then, you didn't have to go to church. There's nothing you can do about it! Too bad! So that was a good excuse for coming here," she chuckled. "I know that

Sally Lee as a baby in the arms of her father, Tyson Lee. *From the Sally Lee Collection.*

Tyson Lee leaving Swan's Island by seaplane. *From the Sally Lee Collection.*

years and years ago, my godfather, Uncle Teen, had a fire at his house—a chimney fire, I think it was. And it was okay, the fire people came and they put it out. It was a Sunday, and there was a Catholic priest that at some point started coming here. He sometimes would do a service, and I guess he was doing a service for Uncle Teen.

"They had finished the service, and they were having Bloody Marys. And the fire happened, and they all had their Bloody Marys in their hands, and my godfather's wife went and grabbed her fur coat—I guess that was the thing that meant the most to her—thinking the house was going to burn down. And when the fire people got there, they were all sitting on lawn chairs, and Dorothy had a Bloody Mary in her hand and a fur coat on. The priest was there; he probably still had something hanging around his neck. And one of the fire people said, 'I always wondered what those Catholics did.'" Sally laughed. "So that was pretty funny, the image of Dorothy with her Bloody Mary and her mink coat, on the lawn, waiting for the house to burn down." Between cocktail parties, houses catching on fire and tuxedo-clad men in sinking boats, the early summer crowd must have been entertainment worthy of a sitcom.

It took a unique type of person to choose Swan's Island as a vacation home. Many came out before there was electricity, indoor plumbing or ferry access. It was an adventure. Sally tried to explain how the make-do spirit has endured over the decades: "My mom told me that when she first came to this house, almost everything was painted brown. And she said, 'You know,

someone must have had a gallon of brown paint. And so that's what they painted everything.' And that's kind of fun—figuring it out. I like that idea that if you're making something and you don't have the ingredients, you have to change the recipe."

She laughed. "I mean, I know it's really quaint because I come from New York City, where you can get everything. The other day, I made a pie, an apple pie. I went and picked the apples, and then I made the pie. And then I took it to the church lunch. And it just, you know, made me feel good. I know it's completely stupid and an illusion of something. But that's just it."

There's that indefinable thing that draws people out here—whether for a vacation or for the rest of their lives. You can get natural beauty in plenty of places, but out here, there are deeper connections to people and memories. Everyone's got a reason to keep coming back.

14

ISLAND GARDENS

Vegetables Among the Deer and Rocks

My typing fingers are ringed with dirt after the first gardening day of the year. Island gardens aren't that different from what I'm used to—apart from the layer of seaweed I spread last fall and the mussel shells that keep rising to the surface no matter how many I remove. I'm also not used to having to keep all plants in maximum-security prison mode. I left the netted gate open late last August and returned to find a vacant brown pit and a few beets with raccoon tooth marks.

The island deer gang also plays a fun role. The Internet informs me that your average deer, when threatened, can clear an eighteen-foot fence. I can't imagine a situation in which anything would startle a deer enough to make it think landing in the middle of my five- by six-foot garden is a great idea—but hey, famous last words, right?

I rely on a couple of raised beds to keep vegetables off the rocky soil. My part of the island isn't great for growing things, though it's certainly done. Those familiar with Swan's Island will know about the curiously different environments in its three main regions. Swan's Island Village and Minturn can be mired in fog and gloom or wind and rain while folks in Atlantic sip lemonade on sunny porches. Atlantic's known for its better soil conditions and currently holds the island's largest garden. Sue Wheaton churns out enough vegetables to supply neighbors and visitors out of her farm stand, which can be reached by following the yellow road lines until they stop. Her part of the island has problems of its own, though; the first time I met Sue, she was yelling, "Hey, Paul, do your coon dogs hunt beavers?"

Ellis R. Joyce standing beside a tall corn stalk, circa 1920, Swan's Island. *From the Gwen May Collection.*

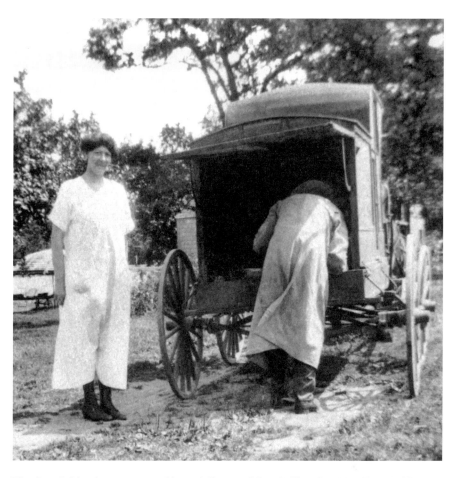

The Swan's Island meat man making a delivery to Mary Sullivan in 1920. *From the Alec Munsell Collection.*

There's a long tradition of gardening and farming on Swan's Island, though fewer people rely on their own crops now that the ferry can get you to Ellsworth in an hour. Carolyn Martin told me how it used to be: "When we moved here, believe it or not, there was eight stores. And you could get the necessities, but you couldn't buy your vegetables—your fresh vegetables and anything like that. And they didn't have too many meats 'cause the time we moved here there was no refrigeration." I've since learned that at one point, a meat man made deliveries around the island.

Carloyn's family used to have a farm in Gorham. They moved to Swan's Island in the mid-1940s, and her father brought the farming spirit with him.

"He always was a believer in a garden," Carolyn explained. "He always had a big garden, and when I got married, I had a big garden. And I canned and froze enough vegetables to take us all winter. And then you could get a deer or two—what you needed to eat.

"Of course, on the mainland, we would have probably three acres of just vegetables. Here there wasn't enough room for that. But we had vegetables and our own fresh milk and everything. And when my mother wanted to make short cake, she had a pan that set in the milk room. She'd go out and flip that cream off of there and come in and whip that up—oh! You don't buy whipped cream like that anymore." Carolyn sighed.

"I didn't have a garden myself for years, but there was an old man down the road, his name was Clyde Torrey," she said. "You've probably heard of him. He come up one day, and he says, 'Why haven't you got a garden for these kids?' Well, I said, 'How do you expect me to plow it up, stick my nose in the ground?' Up he come the next day with his ox and his horse and his plow and his harrow and all the seeds. And he made my garden.

"Anyway, that was my first garden," she remembered. "And I beat him in the size of my beets, and wasn't he mad with me! But he come up every year after that, as long as he lived, and plowed my garden."

Well, hearing that, I can't get too proud of my few tomatoes and handful of beans. But boy, will they taste good!

SHIPWRECKS AND OTHER EXCITEMENT

E nough of this dull social stuff," you might be thinking. "You live in the middle of the ocean—where are the shipwrecks? The pirates? The near-death experiences?" Well, as a matter of fact, I was just getting to that.

It's easy to forget you're living on an island sometimes. In the daily routine of cornflakes, computer work and washing dishes, I don't necessarily experience much awe at nature's power. But of course, that's what the ocean is all about. It's a force beyond human reckoning, loved and feared, with the power to give and to take away.

We have our reasons for living in the middle of it. We're drawn to its resources, whether we're seeking a lobstering income or a killer view from the porch. But there's more to it than that. There's something necessary about it that can't quite be pinned down—the way you need the waves to be there. It's not just some sentimental idea. It runs deep. Many islanders have lived hard lives, but somewhere along the way they chose to be here.

There are times when the harsh side of island life makes itself known all too well. Work on the water supports nearly everything out here, in one way or another. Most families depend on fishing, and in turn, the school, store and everything else depends on fishing families. And no matter how many new gadgets are invented, ocean life will always have its share of dangers.

Historically, Swan's Island saw many more tragedies at sea than we are burdened with now. The island once boasted a busy traffic of goods and large fishing vessels. Swan's Island ships traveled the coast and exposed themselves to more dangerous situations.

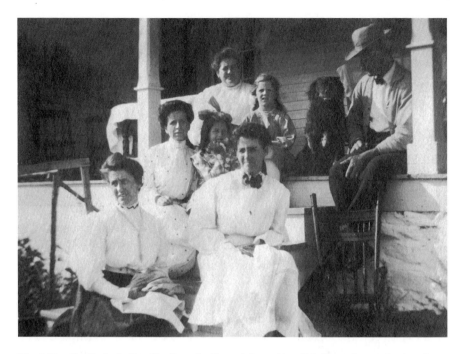

The Milan family, including Nettie at the front right and her lighthouse keeper husband, Orrin, on the porch of the Burnt Coat Harbor Light Station, early 1900s. *From the Milan Collection.*

The steamer *Governor Bodwell* hit the Spindle Ledge and sank in the mouth of Swan's Island Harbor on January 26, 1924. All people aboard were rescued. *From the Gwen May Collection.*

Frank Sprague was mate of a schooner that returned from a voyage to South America on July 10, 1891. As the ship pulled into the wharf at Hoboken, New Jersey, a rope broke, and he fell overboard to his death. Other accidents were closer to home, such as Austin Stanley's death in 1931. Austin went to haul his lobster traps in rough weather, and his boat was later found washed up on nearby Scrag Island. According to the research of islander Albert Buswell, there were sixty-eight known deaths by drowning between 1820 and 1980. The number has dropped off dramatically since then.

Writer Elof Bernstorff records an account by Nettie Milan, the wife of lighthouse keeper Orrin Milan, who kept watch over Swan's Island's waters in the early 1900s:

> As she recalled the days on Mt. Desert Rock, a faint shudder trembled through Nettie's frail body. One day for instance, she stood on the shore and watched Captain Milan struggle with death in the boiling water. C.W. Thurston, an assistant light-keeper, attempted to leave Mt. Desert Rock in a small boat which capsized, throwing him into the breakers. Not able to swim, the strong undertow threw him against the rocks until he became unconscious. Captain Milan rowed into the breakers but was unable to reach the helpless man. The captain went ashore and tried to catch the body as the sea hurled it onto the shore. The second attempt succeeded, and with the help of the woman at the station, he dragged the man to safety. Thurston had been in the water fifteen minutes. It took two hours to bring him back to life.

Nettie also told the story of the Rockland steamer *Governor Bodwell* catching on fire. "The crew was up to the Odd Fellows Hall. Everyone left the dance, and the boys all in their Sunday clothes, hauled her off while she was burning." The boat "died" where it sank in the harbor.

Probably anyone who has spent much time on the island will have at least one story about frightening times on the water. I myself can impress mainland friends (though not islanders) by telling them about rough winter ferry trips when the waves crash over your car, freezing a hard layer of saltwater on your windshield. It's equal parts frightening and a pain in the butt.

Even when the water itself isn't causing your problems, it stands as a barrier between you and assistance. Swan's Island has a very skilled and dedicated group of EMTs and has benefited greatly from its new health center, but for the most part, doctors and hospitals are all a ferry ride away. The ferry makes emergency trips when necessary, and we also have LifeLight to helicopter away anyone in real trouble.

Donna Donley and Bonnie Holmes told me about the excitement of making a medical run before the ferry days. "When we had to go off island to go to the doctor or the dentist or whatever, it was always by lobster boat," Bonnie said. "And it seemed to be low tide every time. The ladder seemed to be two stories tall. Usually Gene Norwood took us by boat. We all made appointments at the same time. But my dad would get behind me—he'd stand, walk up the ladder behind me. I was just petrified."

"We went on the *Seawind*," Donna said. The *Seawind* was a privately owned boat that made regular runs to the island. "That was scary," she remembered. "We were all quite excited when the ferry came. But it really changed the island a lot, too." Making the six-mile journey to the mainland in small boats at unplanned times, folks had good reason to be nervous.

"I had a bad experience at the Quarry Pond, you know," Donna told me. "I was swimming one day, and I happened to be with Melita Staples, who was watching me. I don't recall any of it. But a young lad threw a Coke bottle and hit me in the face, and it knocked me out. And Melita came running to my rescue and got me out. My dad was lobstering at the time, so we took his boat over to Southwest Harbor, and they stitched my face up. I'd lost my front tooth.

"Anyway, that night on the way back, he decided we'd start out. Something went wrong with the engine. It was very, very foggy, and here we are stuck out in the middle of the Atlantic Ocean, me just coming from surgery. So we kept going. We could hear boats going by, but it was so foggy they couldn't hear us. The next morning, they were in the process of working on the ferry terminal for the boat. Finally, some of the workers heard my dad yelling for help. So they got us and took us to the island. But Mom held me all night while she sat on a lobster crate. So that was an experience."

It took bravery, luck and a touch of desperation to head out to sea in earlier days. Whenever possible, the lack of communication technology was compensated for by the network of seafarers, all of whom kept an eye and ear out for one another. Longtime summer residents Fred and Lillian Pease remember that network in action. Local fishermen took the newcomers under their wings, sure that they'd get in trouble if left to their own devices.

Fred talked about first arriving on Swan's Island. "We didn't have a car, and that was fine," he said. "The first thing to do was get a boat. "So with advice from Carroll Staples, the present Carroll Staples's grandfather, I got a skiff built by Rich over in Bernard. We got an outboard motor, and that was our family transportation. And we would go off to the beach. If the fog came in while we were at the beach and we were hung up, I knew that we could

get in the skiff and pick our way through the fog to the Carrying Place, and there would be Richard LeMoine."

"He took care of us," Lillian chimed in. "And took care of the house. And he was standing there when we came out of the fog with a car to take us home. But we always told him where we were going when we left here." The couple laughed to remember their guardian angel. "I mean, you talk about people looking after people," Fred said. "Obviously, people looked after us because I'm sure they thought we didn't know what the hell we were doing."

The fishermen watched out for one another, as well. They had a sense of where people were headed and knew to check up on someone if they didn't get back in time. Maybe that's where the tradition of nosiness originated; you never knew when it just might save a life.

In these days of a convenient ferry and solid roads, the separation between island life and mainland life might be more mental than physical. We separate it from any other place by keeping up on the gossip and poking around and helping out. We make the island an island.

KICKING UP YOUR HEELS, ISLAND STYLE

When I first came out to Swan's Island, I was excited to hear that there was a history of local music and dance. As a freshman at Bates College, I was introduced to the Maine music and dance scene the way all popular kids are: folk dancing! Contra dancing was one of my primary ways to get out and meet people who actually lived here, as opposed to those who breezed in for four years of thrilling academia.

Contra dance, for those of you who haven't taken the plunge, is a traditional New England–based dance accompanied by fiddle music. These days, you can find it all across the country. It branched off from the same source as square dancing, so you hear things like "do-si-do" and "swing your partner," which might be familiar from embarrassing childhood gym classes.

So, back to the island. My pal Sonny Sprague scared the heck out of me during my job interview for this position, sitting quietly and looking like a selectman (not that I knew what that was at the time). As soon as I mentioned that I played a little music and was hoping to organize dances, his ears perked up, and I thought maybe he might not push me off the ferry dock after all.

Sonny liked his dancing. He told me about a time he missed a dance in his youth. "I still hold it against Mom and Dad," he said. "I was in the army in Virginia, and I came home on a three-day pass for the Fourth of July picnic and the dance. I pulled up in my little red Volkswagen, exhausted, worked on the picnic, and I was so tired I fell asleep. They never woke me up. I spent the night over there sleeping with the Merry Mariners playing up at the Odd Fellows Hall."

An unidentified stylish couple dancing. *From the Donald Carlson Collection.*

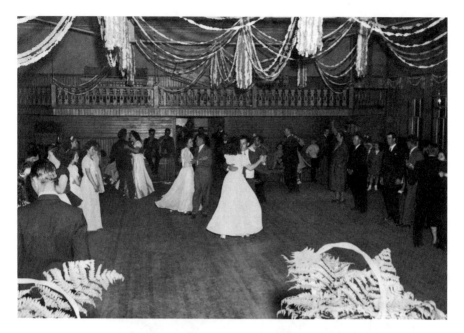

A formal dance at the Odd Fellows Hall, circa 1950. *From the Joyce Knight Collection.*

The dances Sonny remembers were at the Odd Fellows Hall, though there also used to be dancing at the Redman's Hall and other island venues. "When you went to the dance, you went to the dance," he said. "You dressed up in your Sunday best. Kids dressed up. It was a family time."

There was a general formula to the evening, Sonny explained: "Dance probably started eight, nine o'clock at night. There'd be someone taking tickets at the door on the second floor. Rebekahs (the Odd Fellows sister organization) would be there with Kool-Aid and tuna fish sandwiches or cookies or something at intermission. They'd play for half an hour or an hour, then it'd be about a fifteen-minute break. There'd be dances, Virginia-reel type stuff—we called 'em contra dances—probably four or five times a night."

The musicians were often local, though bands would travel from places like Rockland and Stonington. Sonny remembers Bob and Dick Holmes, Ray Stinson, Maxine or Merrill Orcutt and a few other folks. "It was swing music," he said. "Foxtrot. You know, the 'Missouri Waltz' and 'Five Foot Two, Eyes of Blue.' Then someone would come on from the mainland and stand upstage and do clogging, soft-shoe stuff." A single event had a variety of different dancing styles, which set it apart from the modern contra dance.

At one point, the island had two or three dances a week. Visitors would come in off their yachts to join in. The dances Sonny remembers were in the 1960s and early 1970s. Things changed over the years with new music and dance style, and the contra dance died out. People have been glad to see it start up again in my past two years on the island, although not too many are left who remember the old dances.

The second floor of the Odd Fellows Hall fills up with friends, family and neighbors spinning and tripping and laughing together. Not many mainland dances have kept that true community spirit, where your partners are the folks you've known your whole life. There are babies bouncing along in laps and teenagers dancing with eighty-year-olds. It's a wonderful thing to experience.

GHOSTS, ZOMBIES AND SCARING ONESELF SILLY

Everyone has at least a couple moments in life when they realize they are doing exactly the sort of thing that, if done by a character in a movie they're watching, would make them think, "Oh man, that guy is totally about to die." I live alone on an island in Maine. Red flag! But don't worry; it's fine. This is just a preface to tales of the haunted underbelly of Swan's Island.

To the best of my knowledge, the Wheaton home (my current residence) does not house any malignant spirits. One possible exception is the mouse that drowned in my toilet, whose wronged spirit might have sent its brethren on the mission of vengeance that resulted in some of my oatmeal being stashed inside a container of salt, ruining both. In the world of unpleasant mouse encounters, this is what's known as a "twofer."

The animals on Swan's Island do have a dark sense of humor. Last year, the island raccoons decided there wasn't enough food above the ground and started to tear up patches of turf to dig for grubs. Hunks of brown grass were piled up all over the place, exposing the dark soil below. On island lawns, this was unsightly. In the Rose Hill Cemetery, it caused at least one person (me) to immediately think, "Zombies."

Like any respectable place, Swan's Island has its share of ghost stories. The book *Peripheral Visions* by Judith Monroe is full of local legends: the woman who walks through the clam flats holding a baby, the ball of fire that appeared in front of two kids, the beckoning woman at the lighthouse. Everyone's heard of something or other.

The Cloud House. This was once the home of Walter and Etta Stockbridge Joyce and is supposedly haunted by their daughter. *From the Gwen May Collection.*

Wesley Staples owns what is still known as the Newman House from its original role as Garland Newman's store at the turn of the twentieth century. Wesley bought the house in 1989 and began a flurry of renovations, removing the downstairs walls and every interior door. Three nights after the commotion started, one of his guests told him they heard someone walking up the stairs at night.

"I jumped out of bed, flicking lights on as I went. Nothing. No one," Wesley said. "But from that night on doors slammed day and night, screen doors opened and closed at random, there were continued creaking sounds on the stairs. We never saw a thing—until one evening I was standing at the kitchen cupboard and heard a door open to the stairs.

"In the split second before turning around, I thought to myself, 'But there is no door. I took it off.' In the open space, I saw the figure of an old mustachioed man wearing a wool vest. He was heavyset with a stare fixed on me. Angry! I blinked my eyes and he was gone. I chalked this up to exhaustion, but it was not a good night's sleep that followed."

Over the course of the next year, Wesley heard plenty of stories about his "guest." People even gave him pictures of the house back when it was a store. "Standing on the front steps in one of those pictures was the man on the stairs, old Mr. Newman," Wesley said.

"Seventy years before I moved in, he had hung himself from a rafter in the barn that was once behind the house. Seventy years he had stayed behind looking for release. I don't think he liked my taste. My changes—no doors and no walls, sliding doors and sunlight—turned him away because by the end of that summer, he was gone. Nary a sound! No sightings! Gone until

last summer, that is. In September, a renter called: 'We had a lovely time but have you heard the slamming doors or the stairs creaking at night?'"

Carolyn Martin talked to me about an experience she had out here when she was about twelve years old: "I saw my grandmother. Everyone thinks I'm crazy, but I wasn't. I was settin' down by the kitchen table, and I said, 'Well, hello.' She was standing at the cellar door. Daddy says, 'Who are you talking to?' I said, 'Grammy.' He says, 'There's nobody there—there's just Rosie coming up the road.' She come up to tell him his mother had passed away. And I swear I saw her standing there. Nobody ever believed me."

You'll find divided opinions on ghosts out here like you will anywhere. Plenty of hauntings can be traced back to pranks, such as the "cowsucker"—a white sheet pulled across the road in front of passing cars. Another classic was the "devil's fiddle"—if you run a thread under the clapboard of a house and "play" it, an eerie noise is produced inside the house.

Carolyn has a sense of humor about her encounters. She also told me about a night out with her friends: "Janet and Barbara and I was with Gayle driving her father's truck. And they had told us that over to the harbor there was a ghost in the cemetery. So, okay, we go. Well, Barbara was sitting in my lap, and she had on a white kerchief. She turned like that, and she started screaming. She saw that white kerchief in that window! Poor Gayle, she hit a tombstone. It was so funny! I told her, I said, 'Barbara, you idiot, that's *you*!'"

In an interview with Meghan Vigeant, Normie Burns described riding his bike on the island around age ten or twelve: "My aunt never had a car," he said, "and she'd get me going to the store up here that Myron Sprague owned. To get her groceries and put them in the cart. Nighttime I was always nervous coming round the corner 'cause of the two houses. There was one house up there was called the Crag Top.

"Well, Johnny Wheaton and Jerry Smith used to tell me about this ghost. They said the ghost'll reach right down and grab you by the shirt and pull you right off the bike there. Well, I come down by there if it was after dark, and I'd look up thinking that ghost was gonna grab ya. Well one night, my pant legs caught in the chain. I went over the handlebars, all flying. But the ghost never got me," he laughed. "I kept looking."

It seems that at least a good portion of the island's otherworldly encounters have been since established as pranks or mishaps. Gwen May told a story of her sister Lottie spending a night at a friend's house listening in on phone calls on the island's old party lines.

"They picked up the phone one night, and they heard these women talking, these old ladies. So I guess Lottie let it be known that she was on the

A young island boy out for adventure on his bicycle. This is Richard "Dick" Jellison in the late 1930s. *From the Richard Jellison Collection.*

linc and said, 'Who is this?' The lady said, 'This is Bessie Joyce.' Well, there were two Bessie Joyces, and Lottie knew only one of them—and she was dead! The one that she knew had died, and she didn't know about the other one. And when that woman said she was Bessie Joyce, Lottie freaked out," Gwen laughed. "She thought she was talking to this dead woman, and she hung up. She didn't try that again!"

I think the latter story is the one I'll keep in mind when I hear clunks in my old island house on lonely nights.

18

DIRTY LAUNDRY ON
SWAN'S ISLAND

Time to talk about Swan's Island's dirty laundry! This isn't knitting group gossip—I mean laundry literally. As a member of a generation with notoriously poor housekeeping skills (or is it just me?), I'm pretty darned proud when I get my laundry attached to the line securely enough to keep the sea breeze from lifting it next door.

You can imagine my surprise when I learned that, at least on Swan's Island, there is a right way and a wrong way to hang laundry. This extends past my only rule: "Try to keep your underpants where they can't be seen from the road" (a good rule of thumb for both laundry and life in general).

Donna Donley, who grew up on the island, talked about the time her sister Jean Ranquist visited her first home. "She came in and she said, 'You haven't got that laundry hung right!' I had one towel maybe an inch down from the one that was beside it."

Donna laughed. "She talks about that to this day. I mean, that's how particular some people were, and I was that way, too. I had to hang all the long towels together, all the hand towels together, the wash cloths…everything just so."

Candis Joyce's family felt the same way. Her mother even put wet clothes in the hamper in order so that they'd automatically be in the right position to hang on the line. Families had their own ways to hang things and thought other women were imbeciles when they got it wrong. Candis also pointed out that you could tell a lot about a family's personal life by what they had up on their line.

Going back, the laundry was done by hand—scrubbed and then cranked through wringers that left scars on many a curious child's hand. Bonnie

Jean Ranquist monkeying around on a Swan's Island tree with a laundry line in the background, 1958–59. *From the Gwen May Collection.*

remembered her neighbor Marguerite Orcutt washing cloth diapers on the porch. "She had, like, five buckets. One to scrape…" Bonnie trailed off, laughing. "It's gross, but this is what they did. She'd use all buckets. So after the last one, they'd come out clean. She did that day after day. They didn't just buy them and throw them away, back then."

For a while, Dorothy Stockbridge had three kids in diapers at once. "I'd have one big line of diapers, a line of onesies, nightdresses, a line of undershirts, bellybands—they used bellybands then—and lines full of baby clothes. Then I'd have to take another day and do the regular clothes. I didn't mind it." She laughed when she told me about a neighbor walking

Island girls not worrying about laundry, circa 1940. *From left to right*: Frieda Tinker, Melita Smith, Velma Morse, Mary Burns and Helene Burns. *From the Gwen May Collection.*

over the hill and seeing the lines strung everywhere. "He'd say, 'Dorothy, you must be awful dirty or awful clean.'"

There were lots of tricks to the trade. You could tell by the smell and feel of the wind if it was a good drying day. Hanging overnight would keep the sun from bleaching colors. Some even said drying on a foggy day would get rid of mustard stains.

Bonnie Holmes's mother hung her laundry outside in the winter, let it freeze solid and brought it in at the end of the day to dry on a rack over the furnace. "They would smell so good, those clothes," Bonnie said. "And my sheets—oh!"

The work wasn't done after drying. One of Bonnie's chores was to do the family ironing. She thought some of her work was a little excessive. "Handkerchiefs, oh gosh! Pillowcases and sheets—why? To this day, I don't know why I had to do that."

Now that I've done my research, I feel I ought to reform my ways. If nothing else, it will do justice to the clotheslines I use at the former home of Lenora Wheaton, who was by all accounts a meticulous housekeeper. Guess it's back to the ironing board.

19

GRADUATION AND GOODBYES

We're nearing the end of graduation season, a time when people think back on their youth with longing and/or embarrassment and wonder what on earth they're going to do with the extra cake and balloons. I attended the Swan's Island School's eighth grade graduation this year—an event that did not exist in my own school but which is a big deal out here. In Cazenovia, we moved from eighth to ninth grade by shifting our books and gum wrappers from the lockers by the football field to the lockers by the science teachers. Our physical progress through the grades was gentle; we went from hall to hall like dogs following a trail of biscuits to some surprise location.

There's a lot more at stake out here. In a K-8 school, eighth grade marks the end of waiting for the bus at the bottom of your driveway, the end of your parents dropping by school with that permission slip you forgot, the end of being surrounded by people—from your classmates to your teachers to the lunch lady—who have all known you and your family for years.

Many kids never return to live on the island after leaving for high school, especially if they continue on to college. With limited job options on the island, putting a college degree to use usually means finding work on the mainland. Swan's Island's children have spread across the country, often to return only for holidays or possibly retirement.

Gwen Staples May and Clint Staples are siblings who both grew up on Swan's, though only Gwen ended up making her permanent home here. They both remember their graduations in the early 1960s. At that point, the event was held at the Odd Fellows Hall. "We would start practicing

The girls of the graduating eighth grade class of Swan's Island's Elementary School, June 10, 1954. *From left to right*: Nadia Norwood, Diana Orcutt, Margaret Davis and Barbara Smith. *From the Christal Applin Collection.*

graduation maybe a couple or three weeks before it happened, and it was a big event," Clint explained.

"The hall would fill up. I was the—I don't know the name. Grand marshal, I guess. I was tall, and somebody apparently thought I had some rhythm because I was the guy who had to stand in front of people walking backward with a broomstick decorated with tape. My mother was very good at wrapping the broomstick with different kinds of ribbon. And I would have to swing it up and down to the beat and make sure everybody stayed in step."

Clint said all the students had to give speeches. "Oh, I always got scared. Having a little speech to make or just being up there in front of a crowd and being totally out of place, in clean clothes—not necessarily clean, but you know, better clothes. I didn't like getting all dressed up."

Clint remembered his mother's grooming: "She would see that my hair wasn't right, and she would take sugar, mix it with water and put it on my head. My hair was so stiff with sugar in it—but it held it in place. I didn't like her doing that, but that's what she would do, and everything had to be nice and neat."

Clearly, the siblings had different opinions on the dress code. Gwen had fonder memories of the special outfits. "There was always a dance after graduation, too," Gwen said. "Oh, that was a big deal. The whole island went. We were all beautified up, our hair was done and we just were in our first set of heels. Nylons and all of that lovely stuff. Flowers, corsages and of course boutonnieres for the guys."

She explained the tradition: "The eighth grade graduations here are such a big deal because the kids are moving on to another whole town. Like my kids went away and were gone for four years, home once a month. They're going out in the world like a senior in high school would be going out in the world to go to college. Our kids are leaving just to go Mount Desert Island. But it's out in the world to them."

Lucinda Lowell was one of the many island students who went to Higgins Classical Institute. "It's ninety miles away, and surprisingly enough, there was only one night that I was homesick," she said. "And that was in January. I planned to come home, but we had a big snowstorm and I couldn't go. My uncle came up from Bernard and took me home for the weekend, and when I went back Sunday night, I just cried and cried.

"When I went away to college I was homesick for a lot, which was really weird," she remembered. "I think it was because I had been home with mom and dad for a week before I went to college, and that was

The eighth grade graduating class in June 1961. This is the baccalaureate service held the week before at the Atlantic Baptist Church. *From the Gwen May Collection.*

the year that my brother and sister went to high school. My mother was devastated—sending away her babies. How much she missed them. So I got to school and I missed it, too."

Lucinda talked about how her parents never skipped a school event or graduation, even with all the difficulties of getting off the island. She went to school before 1960, when the ferry came to the island, and as a result they all had to take a small boat back and forth over the six-mile stretch to Mount Desert Island. They also had a store to run. Like many of today's island parents, they had to sacrifice many full workdays to get to the mainland for appointments, sports programs and events.

"I couldn't wait to get home for summers," Lucinda said. "I worked in the store. I just was excited to come home. Our family's got a very close bond; we got that from my folks. We always couldn't wait to come home. And it's the same way now, even though we've grown older and Mom and Dad are gone and we have families—but even our families love to come back. And I've had people mention to me when we were living in Connecticut, 'You go home and you're with your family more than I'm with mine, and mine live

right here in town.' It's a place to be at certain times: Memorial Day, Fourth of July, usually in the fall sometime, Christmas. We're to be together, and no one questions it; we just do it because we love to do it."

Even with their close-knit family, only one of Lucinda's four siblings ended up returning to live and work on Swan's Island—a higher percentage than most families can boast. Like many rural communities, watching children leave to get good educations and jobs is bittersweet. You want what's best for them, but what if that means leaving to become adults and raise their own families elsewhere? And does the wonderful childhood that the island can provide compensate for kids having to leave so soon? Generations of island families have found that it does, as tough as it might be to watch your eighth grader leave on that ferry. And after all, this is home.

Best of luck to these brave students and to their even braver parents!

20

SWAN'S ISLAND'S AMBIVALENCE TOWARD THE CIVIL WAR

To celebrate the sesquicentennial of the Civil War, I've poked around in the vaults to bring you the Swan's Island story. The Maine Historical Society is a great source of information for anyone who wants a comprehensive historical account. The rest of you will just have to trust my simplified version.

Economically, Swan's Island benefited from the war. Fish prices increased, schooners were purchased and islanders saw a period of general growth. This didn't make islanders completely thrilled about the war, however. They weren't the only Mainers who shared this sentiment.

Out of all the Northern states, Maine had the highest enlistment rate in proportion to its population. About seventy-three thousand Mainers went to serve in the Union army and navy, and almost ten thousand never returned. In a small town, an enlistment of two hundred men might mean that one-quarter of the town went to war, many never to return.

Despite these numbers, the state itself was divided in its support of the war. Shipments of Southern cotton had been an important source of profit for decades, and many Mainers were sympathetic to the South's cause. Although it's nice to think of the Civil War as the point when everyone finally realized slavery was awful, at the time, people up here were more likely concerned with the economy and states' rights. Losing the young men who were the strongest working force, as well as greatly loved by their families, was for many a burden too heavy to bear.

There were large peace demonstrations across Maine. After the draft in 1863, "skedaddlers," as the conscription dodgers were known, were

James Joyce II (1793–1873) lived through the Civil War years on Swan's Island. Joyce was a deacon and one of the assessors who signed enlistment receipts. *From the Spencer Joyce Collection.*

attracted to the excellent hiding places in northern Maine. Winter Harbor, a nearby town on the mainland, saw many of its men take off for Canada.

A Swan's Island militia enrollment form from the turn of the nineteenth century gives an idea of who was eligible around that period. By default, all male citizens between eighteen and forty-five were subject to military duty. The following persons were declared exempt from service: "idiots, lunatics, paupers, common drunkards, and persons convicted of infamous crimes." You were also in the clear if you were a postal employee, pilot, Quaker or the vice president of the United States. Frankly, I think the first batch of exemptions would be easier to achieve—and some Mainers certainly did fake decrepitude to avoid fighting.

Entrance to the Sea, by John Bischof. A windjammer sailing in Swan's Island waters. *From John Bischof, Swan's Island Educational Society Collection.*

Another exemption was granted to those employed by merchants, who were needed to continue the necessary transport of goods during wartime. This was more relevant to coastal residents. Eben T. Smith (1827–1871) was a mate on a Swan's Island schooner. On August 1, 1862, he wrote to a government representative for clarification:

> *I take the liberty to write. First are men employed on the ocean liable to do military duty, if not what shall be done with the names of those enrolled that follow the sea? Second are commissioned officers liable to be drafted for privates? Some men have demand[ed] their names to be struck from the enrollment.*

Despite their isolation, Swan's Islanders have served proudly and willingly in conflicts over the decades. In this war that famously pitted brother against brother, however, it wasn't just a matter of patriotism. It takes no great stretch to imagine islanders' sympathy for those who wanted to break away and do things their own way (sound familiar?).

Each Maine town was given a quota to fill. Albert Sylvester and George Ames were two Swan's Islanders whose enlistment went toward that quota; they were mustered into the First Regiment of Maine cavalry in March

1864. If there weren't enough men left to send, towns had to supply money to hire substitutes.

A peeved-sounding Cornelius Wasgatt penned a letter to the island in 1866, after the war's end. Apparently, the Plantation of Swan's Island (it wasn't a town yet) had failed to cough up the amount required. The islanders had voted to take on the debt of $7,860 necessary to compensate seventeen men, "for the suppression of the rebellion besides other incidental expenses."

Despite this vote, Wasgatt said, the island didn't pay the full amount. He writes, "No part of [the debt] has ever been assessed, the majority of the people and of the assessors having been opposed to the war and all support of the war from the beginning." Whoops! I would love to find out who ended up winning that postwar skirmish.

DONKEY SOFTBALL AND OTHER SPORTS

Having grown up in the state that produced the Yankees, I know better than to get involved in a serious discussion of sports in Maine. That being said, I think I'll be safe enough sticking to island sports, which get less coverage on a national scale. And what discussion of island life would be complete without including such an important form of recreation and competition?

I wish I could tell you there was a special Swan's Island sport called "Lobster Hockey" where the players skate on a frozen pond and use giant claws to whack clams into holes in the ice, but there isn't. Maybe if this book becomes an island-wide hit a few kids will try it, and within a couple generations, everyone will assume it's an age-old tradition. Fingers crossed!

In the meantime, I'll stick to the sports that exist. At this point in time, the most visible island sport is basketball. Apart from a weekly adult league, there's a school team that holds the majority of the boys and girls between third and eighth grade. With such a small school population, the kids don't need to decide if they're sporty or bookworms or musical or funny. They just do it all. Kids who wouldn't set foot on a court in a larger school can be found on Swan's Island happily dribbling along.

I've seen my share of middle school basketball games, but none quite compares to Swan's Island's. Due to the multi-age classrooms and the fact that mostly everyone plays, the team is an excitingly mixed bag. Some kids come up only to their opponents' waists, but their courage doesn't fail. Some would visibly rather not ever touch the ball, but they still get playing time. If you want to picture it, think of what it would be like if someone set you down in

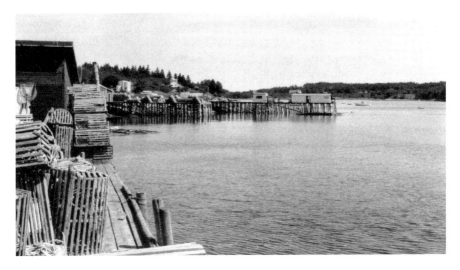

There might be water everywhere, but land sports dominate on Swan's Island. *From the Sally Lee Collection.*

the middle of an NBA game, passed you the ball and said, "Go!" From their confused expressions, you'd think that they had just been tossed a hedgehog. But these island kids manage to pull it off and form a great team. To lead such a group requires skill and patience—fortunately the island has both.

The basketball coaches are husband-and-wife duo Eric and Leah Staples. They both go lobstering, but Leah multitasks during the school year and becomes PE teacher, health teacher and the coach of whatever's going on that season. Leah might be the friendliest person ever. She voluntarily takes charge of every single student in a gymnasium, which everyone knows is the worst place in the school if you want kids to stop yelling and falling over on purpose. Her voice is often gone by the end of the day, but she survives.

Sports are a little tricky on Swan's Island. You wouldn't have anything fancy like two sports options per season because you physically don't have enough kids to make a soccer team *and* a field hockey team. Our teams practice on the island and occasionally travel off on the ferry to play against another school. A few times a season, another school comes out to the island, which I imagine is pretty exciting for them. When this happens, the gym is packed. Not just parents show up to watch their kids. It seems like everyone is there, thoroughly getting into the spirit of the thing. Last year, the kindergarten to second grade class was even recruited to form a cheerleading squad. It was just as adorable as it sounds like it would be.

The only thing that might top that is the period in island life when donkeys were transported out on the ferry for softball games. Lucinda Lowell told me about the sport of donkey softball. "Well, you're on a donkey and you play softball," she laughed, remembering one of the games. "Mike Camber, his dad got them here and headed over to the Baptist church, down in that field. 'Course, Mike was a strapper. I mean, no one's any tougher than Mike Camber. So here was this little donkey, and Mike was never going to take any guff from that little guy. Before it was over with, Mike was devastated. He never hit the ground any harder in his life than he did that day with the donkeys. Oh, it was worth just that!"

Just in case you think that Swan's Islanders are hiding out in the ocean and couldn't hold their own against a mainland team, I'll give you some historical background material. In the late 1970s and early 1980s, Swan's Island had a (non-donkey) softball team that traveled all over the place, and let's just say some serious butt was kicked.

There had been baseball on the island for years. Like kids around the country, Swan's Islanders gathered up their neighbors and pals and created makeshift baseball fields out of flat ground, old junk for bases and ratty equipment. Some kept playing into their adult years and eventually formed a team that traveled to the nearby (by water, at least) town of Stonington for pick-up games on weekends. After a few years of that, the team started to get invitations to mainland tournaments.

In an interview with Meghan Vigeant, Kevin Staples described the growth of the softball team. "We thought we were the most awesome team there was around, and no one had ever heard of Swan's Island. And we ended up placing in the tournament. I think we came in third." Things were getting exciting. They were invited to be part of the league in Ellsworth, Maine—half an hour away or an hour and a half counting the boat travel. To get there, the team had to take the ferry, rent a van, play a game at seven or eight o'clock in the evening, take the van back and pile into a lobster boat for the trip home.

In case this doesn't seem like a big deal, remember that the team is almost entirely made up of lobstermen. Summer is peak lobster time, full of the grueling long days that pay the bills for the rest of the year. "We did this at least twice a week," Kevin said. "We lost a lot of time, a lot of money in the fishing business."

Bob Nitsche, a longtime summer resident and team member, pointed out the upside of lobstermen playing ball. He had invited the island team to a tournament in his Vermont hometown. "After the tournament was over, I

The Swan's Island softball team in the late 1970s. *From the Myron Sprague II Collection.*

talked to some of the guys back home, and they were all saying, 'My God, those guys are so big! Did you see the forearms on those guys? They all had these huge Popeye forearms—they could hit the ball a mile!' and they were as afraid of us as we were of them."

They played teams from Montreal, Belmont, New Hampshire—over thirty teams from all over the place. Not all games involved traveling. Teams from the mainland also came out for tournaments on the island and either stayed in tents or at private homes.

"The island people would show up," Kevin said, remembering these events. "We had as many as 300 people at our games. People would sit up on the hill by the ball field and watch the games." The current year-round island population is about 330. "We did everything as a family," Kevin continued. "All the ball players and their wives and their kids. We would go to a tournament somewhere, and we'd have picnics together." Dedicated fans like the Carlsons, the Tainters and schoolteacher Lois Anderson followed the team all over the place providing support and food.

"Sonny Sprague was the pitcher on our team," Kevin said. "He was this big grizzly bear standing on the mound. One time when we had to play

games back to back and Sonny had to pitch, they had to actually put an ice bag on top of his head with his hat on top of it because it was so hot."

Sonny and Bob remembered that day, when they played seven games in a row. "We won the first six games, and then by the seventh game, some of the young guys had crapped out, couldn't take it," he laughed. "I'm the pitcher. My arm is hanging down to my knee. Bob's the catcher, so every time I threw a ball, he had to squat. And I know I threw at least eight or nine hundred pitches that day."

"Oh, at least," Bob agreed. "Had to be."

"And Bob had to squat eight, nine hundred to a thousand times," Sonny said. "We got beat by a team from Winterport, Maine. It was some shoe shop. After the game, I couldn't sit down, I couldn't stand, I couldn't do nothing. I was so sore and hurt so bad. I never felt that way before and have never felt that way since."

"It was a good feeling," Bob said. "We lost to the best team and the runner up, and that was it."

The island team came to be known for its players. "We were good sports," Sonny said. "We never did any harm, and we represented the island well. And back in the '80s, I'd go someplace, and a guy would say, 'Hi, Swan's Island!' And I didn't know who the hell he was, you know, but it would be a softball player."

Kevin remembered the team going out on a high note. "We ended up going to the state championships, and we came in third in the state one year—we should've won it," he laughed. "Then the next year, we won another division championship, and we went and played in the New England championships, which was held in New Hampshire. We came in third in New England. And we ended on that note after about twenty years of playing softball. Everybody got older and got married—but the memories, you can't imagine the memories that we had. I don't remember the money I lost the days I played ball, but I'll always remember the memories. It was so much fun."

If you find yourself on Swan's Island, I'd recommend attending one of our games. You won't regret it.

22

MERRIMENT AND MAYHEM
ON THE THIRD OF JULY

The Fourth of July is always good proof that summer has arrived—with its picnics, parades and the fireworks that make it the nervous dog's least favorite holiday. Although the Fourth has traditionally been a big deal on Swan's Island, I should admit up front that I've never been around for one. I head south for my own family's potato salad and hot dogs, which of course are the best in the world.

This holiday was once celebrated in grander style than it is on Swan's Island these days. Current islanders can rely on fireworks launched from wharves and a family picnic or two. Back in the day, however, people went all out. My personal favorite stories come from the night before the Fourth. I don't know if this is an island thing or what, but the evening of July 3 had all the excitement and good-natured destruction that one typically associates with Halloween.

People were out and about. Much of the activity was at "the crossroads," the prominent island location where the one big paved road meets the other. Outhouses were not only tipped over but also transported. Dorothy Stockbridge laughingly denied her involvement as a teenager: "I didn't do it, but I was there!" she said. "I couldn't tip 'em over—the boys done that. One night, they tipped one over and the guy was in the outhouse! Willie Turner. And in the morning, there'd be two, three outhouses on the crossroads and an old couch and chair and old bathtub, and, oh, it was terrible!"

Another favorite target were the punts, or small boats, that many families owned. They vanished and showed up the next morning in various ponds. David LeMoine mentioned a particularly successful year:

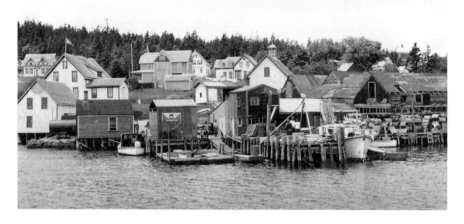

The working harbor of Swan's Island, circa 1950. *From the Gwen May Collection.*

I remember hearing of a time when every rowboat in the harbor was tied to the stern of a boat. They would row them out, and have someone bring them back in, until the last one was tied and that person swam in. At that time many fishermen couldn't swim, and if they could swim out, it would be a challenge to climb out of the water into the rowboat to untie it and row back in. From what I was told, the fishermen ended up finding some rowboat at a summer resident's house and using that to get theirs back.

Dorothy told me about Elden Colbeth, who was determined to get the better of the pranksters. "He took his punt home," she said, "and kept his porch light on all night. He had his punt tied to his garage. The boys sneaked up somehow and cut the rope on the punt and took it to the Mallyes' Pond. He got up in the morning and said to his wife, 'Myrtis,' he said, 'those boys have taken my punt again!'"

Starting in 1960, when the ferry service came to the island, the Fourth of July was celebrated annually with a huge picnic. People crowded onto the island from the mainland. They had games, food, crate races (string a bunch of lobster crates into the harbor and see how far you can run along them without falling into the ocean) and often baseball or a dance at night.

Sonny Sprague remembers the hard work that went into the preparations. "It was about three days of preparing for it," he said. "Wesley and Norman Staples would go with a wagon of some kind and come back with it solid full of potatoes, cabbages...used to have about seven or eight hundred

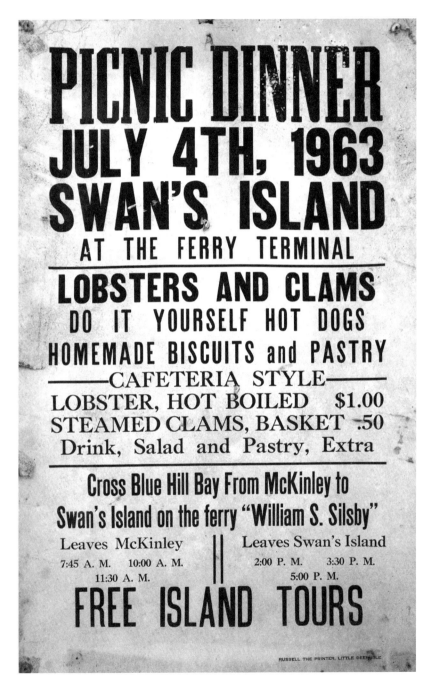

Poster from the 1963 Fourth of July picnic on Swan's Island. *From the Bob Nitsche Collection.*

pounds of lobsters in advance from Uncle Bill." People contributed pies, ice, hoses and whatever else was needed from their own homes. A huge crew of volunteers pulled together to feed the crowd.

"At four o'clock in the morning, I'd be up getting ice from all around town and the chocolate table from Milton Hennigar, and Oakley Smith and Johnny Wheaton would be cutting lobsters, and Richard Kent would be cooking, and Carlisle Staples would be there, and Sheldon Carlson would be selling hot dogs and many more people. It was just a community thing."

Sonny remembers the picnic as a reunion, as well. "See, back then there was a lot of people who had left the island, and the ferryboat showed up, so they said, 'God, let's go back to Swan's Island.' So on the Fourth of July, they would come back. That's where they'd meet. Oh, there was more people hugging and laughing."

Community spirit aside, I'm glad I don't have an outhouse to keep track of.

THERE'S NOTHING LIKE "HOME" RESTAURANT COOKING

Visitors to Swan's Island are often shocked by the lack of options when it comes to eating anything that didn't start out in your own fridge. Restaurants here vary seasonally, as well as year to year. At the moment, we've got a couple different options for dining out. The Carrying Place Market has takeout, and the Swan's Island Tea Room serves breakfast and lunch. Come winter, if you want anything that isn't home-cooked, you'd better strike up a friendship with the Schwan's man.

I like to think that what we lack in quantity, we make up for in quality. There's nothing like hearing the chef say, "Kate's order is up!" It makes a person feel important. Meals out are also a very social occasion, since they're so special. Usually, in the Tea Room, one table gets talking to another until you end up forgetting which people you came with.

There have been a lot of well-loved restaurants out here over the years—primarily run by families for as long as they've got the energy to keep it up. One such establishment was Dorothy Stockbridge's place, the Sea Breeze. She and her husband, Paul, ran it for seven years. They did it all—transported supplies, cooked, served and cleaned. She hired help over the years, but she was the one scrubbing the fryer at the end of the night.

"They still ask me to start another restaurant," Dorothy said, fondly remembering the hard work. "Paul used to go clamming, dig and shuck all the clams, and he supplied all the lobsters. I had a big menu. I had three, four kinds of steak. I had two kinds of chicken. I had lobsters and clams and shrimp and haddock. I had specials, two, three times a week. I really worked hard."

Most island food was cooked at home with ingredients either homegrown or purchased at stores like E.R. Spurling's. Percy Spurling and young Gene Norwood, mid-1920s. *From the Myron Sprague II Collection.*

Dorothy Stockbridge in her Swan's Island kitchen, 2011. *From the Swan's Island Historical Society.*

People have called her up from across the country to ask her secret for the perfect fried clams. "There's no trick to it," she explained, "just have your grease clean. You have 'Supreme' batter, and you beat up your eggs, that's all there is to it. Dip 'em in the egg and the batter."

Dorothy learned her cooking skills and work ethic at an early age, taking care of families and holding multiple jobs. "I cooked since I was ten years old, I think. I cooked for myself and my brothers, and it was a hard life."

Islanders appreciated her efforts. "I used to get a lot," she said when I asked about her customers. "There were certain people that would come every night: Agnes and Carlyle Staples, Mary and Wesley Staples, Russell and Alice Burns, Mrs. Anderson the schoolteacher. I had one big round table that looked out on the water, and they had their names on the chairs."

Dorothy put on a gruff voice to imitate a territorial customer. "Agnes said, 'That's my chair! I'm gonna sit there.' She come in, Kenny Ranquist was sitting there. She said 'Get outta my chair!' It was red—I painted it red for her."

She laughed when I asked if she got vacation time. "No. We took one day off and went to Frenchboro for the picnic. Why, you thought we committed a sin! We come home the parking lot was full. I said, 'Paul, look up in the parking lot!' It was all full. They said, 'Where have you been?'"

I don't know many people as tough as Dorothy, who raised seven kids out here with her own muscle and grit. Even in the hardest times, Dorothy kept a cheerful spirit. "I like working for the public," she told me. "I love people, and I love having people around."

I think Dorothy just about summed up the way a lot of people feel about this place: "I love Swan's Island. I'll never leave, long as I can take care of myself," she said with a smile. "Why would I? I've got everything I want right here."

24

HARD TIMES AT BURNT COAT HARBOR LIGHT

The Burnt Coat Harbor Light Station, known more commonly on Swan's Island as "the lighthouse," is one of our key landmarks. When you've got a first-time visitor on your hands and you wonder what you ought to do with them, the lighthouse practically gives off a gravitational pull. Conveniently, it's also the place you end up if you just follow the main road and stop just before your car reaches ocean.

I won't go into an extensive history of the lighthouse here, since many before me have had space to do a more thorough job. My friendly neighbor Fran Chetwynd recently traveled to the National Archives to study the keepers' logs from the Burnt Coat Harbor Light. She sorted through lots of dull stuff about bulbs and wind to bring back the highlights that I borrow from here.

Before the days of flipping switches, it took effort to keep the light and buildings in order. Following the station's construction in 1872, a series of families rotated through the community as lighthouse keepers. The majority of the log entries dealt with the day's weather and routine maintenance on the buildings and light. A lot of sweeping and whitewashing went on over the decades. Concise and routine-oriented as the entries are, they offer a peek into an older way of island life.

Before the switch was made to kerosene in 1878, keepers burned lard to fuel the light. It wasn't always easy to keep it burning, especially in the winter months:

The Burnt Coat Harbor Light Station. View of a boat under sail passing the lighthouse on Hockamock Head, leaving Burnt Coat Harbor. *From the Gwen May Collection.*

Feb 9, 1875—NW Gale very cold weather at 2 AM so cold could not keep the lights burning had to take them down and heat them on the stove and set them agoing again with hot oil.

Feb 10, 1875—Still cold had to keep a regular watch to keep the light burning the Harbor all closed up with Ice.

The logbooks mark many significant, and sometimes tragic, events:

July 26, 1876—Friday afternoon about four o'clock Mr. Cutler and wife of Boston was here on a visit. Mr. Cutler and wife and my daughter in the lighthouse boat and the boat was capsized and Mrs. Cutler was drowned.

Keepers had a difficult life, taking on sole responsibility for their lifesaving light. There were no vacations in this job:

Oct 24, 1878—Wind SE fresh breeze rainstorm. I have been on the station 3 years and 3 months have not been absent one night from the station in the whole time.

The Lighthouse Service made regular visits to Burnt Coat Harbor to deliver supplies and inspect the premises:

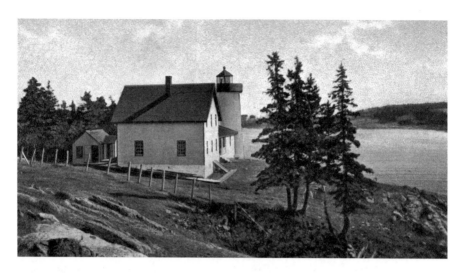

Postcard view of the lighthouse. *From the Marion Stinson Collection.*

April 20, 1880—Arrived US Steamer Iris *Capt. Fisher [?] Johnson with supplies for Mount Desert Rock and landed on this Station 10 barrels of cement.*

Despite their hard work, the keepers' vigilance could not prevent all shipwrecks:

July 5, 1880—A vessel wrecked on Johns Island. Put at one o'clock AM it was foggy. The name was Malanta *of Canning bound for Boston loaded with railroad sleepers one hundred and six tons Register. There was a crew of five men none was lost the wreck was sold at auction as it lay on the rocks the proceeds was about four hundred dollars. Saved a large part of the cargo and the sails and anchors. The vessel was said to be seaworthy at the time of the disaster.*

March 7, 1882—A vessel wrecked on Black Ledge at 1 o'clock PM in a thick snowstorm Name J W Sawyer *of Portland, ME, bound for Portland from fishing banks loaded with fresh fish. One hundred and 15 tons register. Was a crew of fifteen men. Three was lost—the remaining twelve was brought to Swan's Island. The vessel was a total loss.*

Wrecks were probably inevitable in an era that saw much busier shipping traffic:

July 29, 1880—there was 29 schooners passed the light today.

A few islanders still remember the active lighthouse days, mainly children invited over to play with the keepers' families. Like the rest of the island, the buildings have changed with the decades. The commendable efforts of folks around here have led to a restoration project that has firmly secured the Burnt Coat Harbor Light as a destination for years to come. And though I'm glad I don't call it home, it's certainly worth a visit.

SUMMER MIND GAMES ON SWAN'S ISLAND

S eeing as the rain's let up, I thought I'd provide a helpful guide to summer recreation on Swan's Island. We offer something for everyone: sailing, strolling, beachcombing, kayaking, jogging, swimming and even (a personal favorite) sitting around just looking at things.

The trick to really enjoying Swan's Island is to befriend someone who lives here. I don't count because I don't dare give away any details. But there are neat little places all over the island that require either a knowledgeable guide or a willingness to get very lost. Fortunately, this makes those places that much more exciting.

There are a few island beaches that are particularly popular and accessible. There are those that don't allow dogs, which have signs saying, "No Dogs." Then there are those that do allow dogs, which have signs saying "No Dogs" but don't have any other cars parked nearby.

You can camp, but naturally you ought to ask someone if you can use their property first. You must never start a campfire on Swan's Island. Many of our trees are short-lived since their roots don't have far to go before they hit granite. They have, therefore, developed the habit of transforming into kindling at an alarming rate.

If you're looking to motivate yourself to exercise, beautiful island scenery is powerful incentive. There are sandy parts, rocky parts and mossy forest paths. You might even find some scenic surprises—on one memorable shoreline walk, I interrupted a skinny-dipping lady. She was far enough away to remain anonymous, but I had to take the long way

Islanders on a beach picnic, circa 1930. Amy Joyce Staples, Herman Staples and Dorothy Joyce Rackliff are present. *From the Gwen May Collection.*

back to the car out of embarrassment. If you're reading this, ma'am, I didn't see anything!

Many forms of island entertainment haven't changed all that much over the years, though they've been mixed in with other things. Island kids who grew up before the days of digital entertainment had to resort more exclusively to their own imaginations. Childhood playmates Donna Donley and Bonnie Holmes told me about the mischief they used to get up to. They swam in the quarry, roamed on their bikes, picked blueberries and hung around the hotdog stand on the crossroads.

Donna remembered playing with her pal Helen LeMoine in the summer. "We used to go clamming," she said. "There was this little hut down on the shore right where the quarry wharf is, over to the side. We'd steam the clams and eat them, have popcorn, and that was our little camp."

Bonnie played in an old henhouse in her backyard. "I'd go ask my mother if I could have some flour," she said. "I wanted to cook. So I'd get some water and mix up the flour and pretend I was keeping house. There were spider webs everywhere, and it smelled, and—oh! I had a good time by myself, playing in that old chicken coop."

"We had a beautiful tree in our yard. A red maple," Donna remembered. "It had a branch that came way out and I remember getting up in that

Women going for a Swan's Island swim by motorboat, 1961. Catrina Bowie, Anne Bowie Rice, Renie Hamilton and Margaret Bowie. *From the Ann Rice Collection.*

Lessie, Marjorie and Lillian Bridges enjoying a summer afternoon in a rowboat, 1919. *From the Christal Applin Collection.*

tree, hanging from my legs just by my knees, my arms just swaying back and forth."

The girls used to climb a tree in Bonnie's front yard and play a little game with one of the island's old characters, Harry Gott. "He'd walk by," Donna said. "He supposedly was deaf."

"And he'd walk with a cane." Bonnie added. "And he walked really, really slow. And we'd get up in a tree and say, 'Hi, Harry.' He'd go, 'Hi.' And we'd wait till he got a little ways away and we'd go (quieter) 'Hi, Harry,' our voices getting softer and softer and softer. And he'd lift up his cane and keep walking. We'd go (whispering) 'Hi Harry.' And up the cane would go. It's amazing. He could hear us till he got almost around the corner. And we're laughing. We thought it was funny!"

Here's to many more imaginative island summers!

26

HAMMING IT UP
WAY, WAY OFF BROADWAY

I sland life leads you down the most interesting paths. Drawing from a limited population means that people are encouraged—some would say coerced—into doing things that they would never ordinarily do. I wouldn't exactly say that standards are lower, but they might be a little *stretched*.

One of my favorite examples of this is the Swan's Island theater program. Now, don't get me wrong—there have been and will continue to be many wonderful, high-quality performances out here. But whereas in other locations you might audition for a small part in competition with multiple people, out here if you nod "okay" one too many times you end up with a leading role.

Our current theatrical group is the Hockamock Players. In the 1990s, they had the good fortune to gain the expertise of Gene Jellison as director. Gene grew up on Swan's Island, went to Colby College and taught drama in Santa Monica, California, before retiring to his island home.

In a 2009 interview, Betty Carlson remembered acting in Gene's plays. "We couldn't have gotten any better director from Broadway," she said. The first production they put on was *I Have Seen Myself Before* by Virgil Geddes. As an interesting historical note, Virgil and his wife, Mina, were locals for a while. They moved to Swan's Island in 1965 and lived in the old Atlantic Schoolhouse, the building that was later converted into the library and museum and burned in 2008.

The players followed the Virgil Geddes production with *Arsenic and Old Lace*, in which Betty played one of the elderly sisters. "We did a play at least

Betty Carlson working as the Minturn postmaster in her home in Minturn, Swan's Island. *From the Joan Root Collection.*

once a year after that," she said. "I think once we did two." Betty was a regular feature of the island plays, known and loved. "I am a ham from way back," she admitted.

Gene continued directing as long as he was able and passed away in 2012. In 2009, John and Paula MacKay took on the task of leading the Hockamock Players. The MacKays have done enormous amounts of work for the theater group and upkeep of the Odd Fellows Hall, where the programs are staged.

There were plays at the Hall long before the Hockamock Players came into being. I talked with Carolyn Martin and Marion Stinson about the productions they remembered from their younger years. It seems that back then, like now, people were mostly in it for the fun.

Program of the Hockamock Players' production of *Who Dunnit?* by C.B. Gilford. *From the Dot Barnes Collection.*

"Oh, we were awful," Marion confessed. She remembered one of her final plays, *Miss Dill of Dippyville*. "Everyone signed up for it," she said, "and this one wanted this part and that one wanted that part—I got stuck with Miss Dill. Well, that's alright—but there was two or three other ones that wouldn't show up for rehearsal."

Marion helped out by supplying the missing parts. "I knew all the lines so I was them, and them and me!" she laughed. That method had its share of problems, as she explained: "Once in a while, Arthur would say something from the time I went to make one of the speeches, and I'd go right back and repeat what he said. It wasn't even supposed to be in there!"

Carolyn had her share of fun in the play, as well. "Terry Staples was in it, and he insulted me or something, and I was supposed to make-believe slap him," she said. "Well, he told me to do it on purpose that night. Well, you oughta heard that cast go 'gasp!' when I slapped his face! I didn't slap him that hard, but they just went 'gasp!' Wasn't supposed to do that!"

"We used to have a good time, though," Carolyn said. "Made fools of ourselves sometimes, but that's what they wanted to see."

I am constantly impressed by the feats that can be accomplished by a ragtag group. Over the past two years, I've been part of the Hockamock Players' summer musical productions, which somehow emerge out of sheer chaos in the course of a couple weeks.

Last year, we had a musical revue that featured selected highlights from four shows. Being a young female with vocal chords, I was cast as Maria in both *West Side Story* and *The Sound of Music*. I made it out alive. Although not even my parents mistook me for a real soprano, I will never regret taking what might have been my only opportunity to have my own backup group of singing nuns.

Director John MacKay wrote the year 2013's production, *Rockin' at the Palace*. A group of singing sensations from the late 1950s descends on a small dance hall—cracking jokes, crooning and rustling crinoline petticoats. Each forgotten line and missed cue added to the audience's delight. When all of the audience members know the entire cast, they're bound to be forgiving and extra appreciative of strange wigs.

The plays are a wonderful continuance of the island tradition of making your own entertainment. Year after year, people are ready to make fools of themselves for the benefit of the public. And that's really what it's all about.

27

WHEN ROCK WAS A STAR ON SWAN'S ISLAND

There's an interesting phenomenon whereby places named "The _____" develop characteristics that overshadow whatever "_____" originally stood for. Sometimes the practical use remains constant, such as when "The Dump" is where you put your trash. The fun part happens when the place or function changes and the name doesn't.

In my own childhood, this place was "The Trailer." It was just a couple minutes and a field away from my house. The Trailer was our picnicking ground, right on the banks of Chittenango Creek. I can just barely remember when there actually was a trailer there. My grandparents towed it there decades ago to hold dishes and towels and bathing suits—by the time I came around, it was sagging into the dirt and threatening us with tetanus.

The mere removal of that trailer never had any impact on The Trailer. We could hardly give it a more accurate new label like "The Decomposing Lawn Chairs." Over the years, it's become far more than a name for a patch of woods. The Trailer means minnow catching and bug bites and birthday parties and corn on the cob and the sensation of pulling a leech off your ankle.

One such place on Swan's Island is The Quarry. Generations of kids have spent summers swimming in the quarry pond and winters skating on its frozen surface. It was a hugely popular hangout spot and still draws many swimmers. To see it now, you'd almost think the pond was created for this purpose. It's easy to forget that it's really just a side effect of decades of industry and labor.

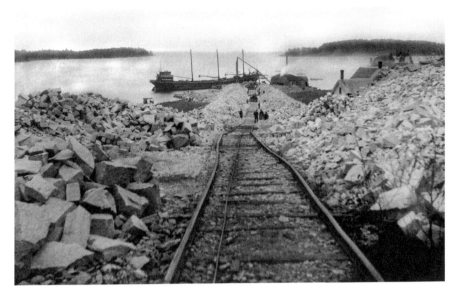

View from Baird's Quarry looking down the rail to the water, 1920s. A three-masted vessel with a pilothouse at the back is waiting to be loaded with the cut stones. *From the Lenora Wheaton Collection.*

What we now know as The Quarry is in fact Baird's Quarry, located in the Swan's Island community of Minturn. Work started there in the late 1800s, and as far as the records show, the Matthew Baird Contracting Co. of New York acquired the site by 1901 at the latest. At that point, it was one of two major commercial quarries on the island. The island also hosted small individual sites known as "motions" because they moved whenever their operator wanted to seek rock elsewhere.

After a few years of labor, Baird's Quarry works grew to be 500 by 250 feet. The industry was supported by huge derricks, blacksmith shops and the boiler houses needed to run the steam drills. If you walk the path above the quarry today, you can see (and climb into) the rusted but sturdy boiler houses. If you scratch below the grass at the southeastern edge of the pond, you can find the scattered remains of the blacksmith site.

A rail ran down the quarry hill to a wharf so that the cut stones could be easily loaded onto waiting barges. A small island called Ringbolt Ledge was part of this transport process. A pulley and cable were set in the ringbolt and used to tow vessels away from the wharf until they could safely raise sail and leave the harbor.

Baird's Quarry granite is a coarse, pinkish bluff and was used primarily for paving stone in New York and Boston. Island quarrymen were expert

stonecutters capable of transforming the sheer rock face into perfect blocks. Fritz Johnson was reported to be the fastest stonecutter of his time and perfected a competitive block-cutting move called the "twist and kiss."

Just in case you wondered how the stuff got here, Swan's Island's rocks are part of the Avalon Terrane—the same as the eastern section of Newfoundland. This was crust accreted onto North America about 410 to 438 million years ago. Gosh! Interestingly enough, we also owe our sandy beaches to the granite deposits. The pockets of sand are derived from the granite outcrops bordering them on either side. The sheltered coves allow for the deposition of the eroded granite sediments. If you happen to be a skilled geologist holding a handful of Swan's Island sand, you can see that it's made up of little grains of quartz, feldspar and biotite—three of the major minerals that make up granite.

Granite quarrying had an impact on Swan's Island in many ways, not the least of which was its role in providing a steady influx of eligible bachelors. Several island families owe their origins to a stonecutter who traveled in seek of work. Men left their homes—even their countries—and ended up on the Maine coast. They found wives and a decent life here and remained long after the quarry work dried up.

Axel Carlson was one such man. He was born in Hansbergson, Sweden, and came to Swan's Island around 1923. In 1926, he married an island girl, Bernice Turner, and settled in Minturn. His descendants still carry on his name there. The Martin and Johnson families also have granite at their roots.

Swan's Island in the early 1900s was quite the happening place. These were the days of steamboats, sidewalks, restaurants and dance halls. Yes, sidewalks seem like a big deal to us out here. It took a lot of workers to make money out of rock and a lot of work to keep those workers working. They needed food, housing and entertainment. Island women ran boardinghouses and cooked for the men—an arrangement that promoted the aforementioned marriages.

The boom didn't last, however. In the late 1920s, the Depression began to slow down industry, and by 1930, the quarry was closed. Older island residents passed on the memory of the steam whistle that signaled the start and stop of every workday. On the final day, they just let the whistle blow until it ran out of steam. Some workers simply walked off, leaving their tools on the hill.

A portion of the quarry's history resurfaced on July 7, 2003, when a group of islanders decided to drain the pond to improve the water quality. While the quarry was in operation, the pond was kept drained during the cutting

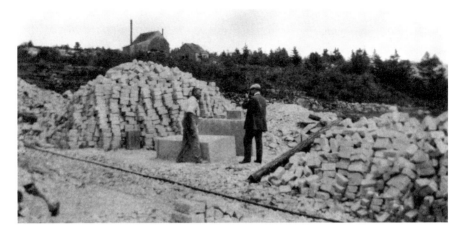

Alec's Motion on Quarry Hill. *From left to right*: Alexander "Alec" Borland (1860–1924) and Herman Staples (1895–1964) by a paving stone. *From the Lenora Wheaton Collection.*

season and allowed to fill up every winter. The 2003 draining revealed many exciting things: tools, old quarry pumps, items lost over the years by swimmers and a handful of unhappy eels.

My island job has been a lot like that of the folks who combed over that exposed rock bottom looking for treasures. You can find some fascinating history if you dig around a little. And as little as the current "Quarry" has to do with its industrial origins, everything feels that much more meaningful when you remember where it came from.

SOME PEOPLE ARE JUST BORN TO LIVE ON ISLANDS

As someone who just sort of accidentally ended up on an island (give or take a few job interviews), I'm always fascinated by the processes that led to other people ending up on one. Even more interesting forces are at play when they decide to stay there.

Bernita Joyce took the shortcut of being raised on Swan's Island, but that by no means lessens the mystery. Her presence here involved generations of moving homes and finding work and falling in love. I had a chance to talk with her at a recent island meal.

Nothing brings people together like food and stories, preferably at the same time. I was invited to a family party a few weeks ago and loaded up on all sorts of delicious things in the kitchen. I suspected I'd probably taken more than I could handle as I staggered toward the table with my plate. That's when I noticed, with excitement and dread, that each place setting also contained a huge lobster. As a guest, I had to finish everything with a smile. I thought I might die, but I managed to rally in time for dessert.

As I tried to find unoccupied sections of my stomach, I was treated to the usual blend of old and new island stories. I was across the table from Bernita, who is one hilarious lady. She told me that my predecessor at the historical society, Meghan Vigeant, kept coming back for more of her stories. "I guess she thought I was a character," Bernita laughed. I decided I'd better listen to Meghan's interview with Bernita and see what I'd missed.

In terms of choosing the island life, Bernita didn't stand much of a chance. She grew up with two island parents and lots of love for the people around

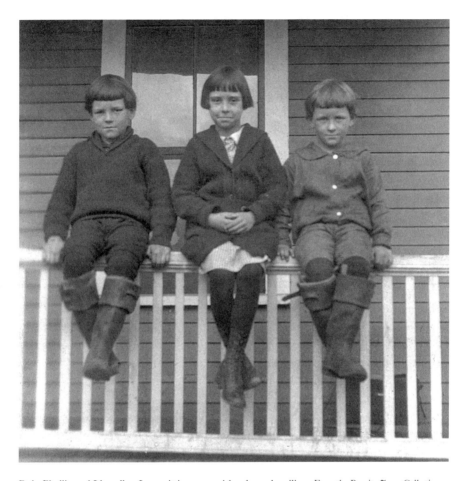

Rob, Phyllis and Llewellyn Joyce sitting on an island porch railing. *From the Bernita Joyce Collection.*

her. Bernita's mother, Laura Green Joyce, was raised on Grand Manan Island in New Brunswick. Her father, Llewellyn Joyce, was a Swan's Island native. They found each other in Rockland, Maine, around 1945. Bernita described their meeting at the Samoset Resort.

"I don't know a lot about it, but I know my dad was in the service," Bernita said. "I believe he was home on leave. At that time, a lot of our relatives on the Joyce side were living in the Rockland area. And if I have this correct, he was there at the Samoset, and he saw these two girls. He had his eye on one of 'em that he wanted to ask out to supper that night. Well, it turned out the one he wanted to ask out to supper was my mother's

sister, Ruth, and Ruth said no. So he asked my mother out, and a month later they were married."

Even after her marriage, Laura had to remain in Canada for a period "until all the red tape got cleared." As a child, Bernita visited Grand Manan once or twice a year. Her grandfather, Robert Green, owned two sardine-packing plants and two lobster pounds there.

Bernita remembers visits to Grand Manan and still has a taste for its dulse seaweed and memorable landscape. "On either end of Grand Manan Island is a lighthouse," Bernita said. "And both ends of the island have these really amazing cliffs. There have been stories written about those cliffs. There's been songs written about them, poems written about them."

Bernita's mother didn't have as tough a time adapting to Swan's Island life as many new wives would. "It was quite an easy transition," Bernita said. "I remember she did tell me that at one time. She said if she'd had to go a city or something, you know, that would have been a big change for her. But moving here wasn't."

She describes her father, Llewellyn, as a good man, if a bit of a rascal. "He went lobstering at a young age because he had to. When he was seventeen, he went in the army, and he was stationed in Guam during World War II." Llewellyn was homesick during the war and wrote letters to his brother Robert, who was unable to serve due to his health. Bernita still has the letters and enjoys reading through them.

"That was kind of fun. Sometimes you find out things about people you never knew. Family secrets and all. He used to tell me, actually, about when he was in the army—some of the things. I guess the hardest part for him was the people that he made friends with that didn't come home."

When Llewellyn returned to Swan's Island, he got his own boat and started lobstering. He and Laura moved into the home that they would spend the rest of their lives in. The couple was known for their music. "My parents used to sing on the CB radio in the wintertime, by request," Bernita said. "People used to get on there and say, 'Come on, Laura and Llewellyn, sing us a song.' My mother played the piano. And they would, they would sing."

The Joyce family—Llewellyn, Laura, Bernita and younger brother Spencer—began singing together at church. Bernita's not sure quite how, but they ended up singing hymns in Maine prisons. "The next thing I knew, we were going to the prison in Bangor and then to the Thomaston prison. And of course, being from Swan's Island, we weren't used to seeing police or anything like that. I can remember being afraid—and the only reason I can think of is because the guards had uniforms on, and they must

Llewellyn Joyce and his father, Guy Carlton Joyce, circa 1943. Llewellyn is in uniform. *From the Myron Sprague II Collection.*

Portrait photograph of Llewellyn Victor Joyce (1860–1936). *From the Bernita Joyce Collection.*

have had guns or something. We used to sing a couple of songs, and then our part was done and whoever happened to be there for a minister would do his sermon."

Bernita wasn't scared of the prisoners. "At the time, I can remember they all had blue jumpsuit things on. And they used to have the ankle shackles—some of 'em did. But they used to sit very quietly. They'd come in single file and set down in the chairs. It was not a thing where they had to come, you know. You got to come if you wanted to."

Life out here can bring you in contact with some unusual people. The Joyce family got a kick out of meeting the rich and famous when they made summer sailing trips to the island. "Usually, if there was someone around, either Spencer or my father ended up finding 'em," Bernita laughed.

"I can remember the first time I ever met Walter Cronkite," she said. "He came here on his yacht. Actually, my brother got to meet him first, of course. And I can remember getting in my father's rowboat and rowing out to the yacht and rowing around and around and around the yacht while

Spencer was setting on the deck of the yacht having a Coke with Walter Cronkite and pretending like he didn't know me. But later on, he came up to my dad's, and I got to meet him and everything."

Apart from a year spent in Florida in 1970, Bernita has made her permanent home on Swan's Island. She explained part of the reason why: "I love it here, in the summer and fall. I guess because I'm older, I'm satisfied being here during the winter. You know, I don't think I've ever had my door locked. Ever. Being an island girl, I grew up here and, you know, I'm probably a little backwoodsy at times, but so be it."

The one downside for her is waiting in line for the ferry, which she laughed about. "And even then you may or may not get off," she said. "Even after setting there for two hours. But if we didn't have the ferry, we'd have a bridge. And I'm afraid that if we had a bridge, Swan's Island wouldn't be Swan's Island—the one that we enjoy. So we put up with the ferry for that reason."

Bernita stands by her home with all her good humor and love of people. If you come out to visit, you can recognize her in her truck with her big white dog, Jack, bouncing happily from side to side in the back. I'm sure she'll be glad to share a story or two and her outlook on island life: "I think we're like a big family, just like brothers and sisters. Everybody fights and squabbles at times, but when someone's in trouble, or someone's sick or whatever, everybody shows up. And everybody supports that, you know."

THE DIY DAYS OF
LOBSTER GEAR

As a warning, this article contains some "back in my day" nostalgia. I'll be borrowing it from others since my own material covers only cassette tapes, sending your film somewhere to get it developed and that time when people thought Beanie Babies were a good financial investment.

Once upon a time, Swan's Island's lobstermen made the majority of their equipment by hand. Fishing involved not only knowing where to go to find your catch but also being able to build good gear to bring it in. The favored designs, techniques and materials evolved over the years. There were hand-carved buoys, wooden lobster traps (also known as "pots"), hand-knitted bait pockets and toggles made from beer bottles. Materials depended on what was available on the island. They chopped branches for the traps and gathered stones from the beaches to weigh them down. I imagine in a small place like this you knew where to go for beer bottles.

The equipment that resulted was really neat looking. Each builder had a unique style. Some fishermen were meticulous in crafting their gear, taking careful measurements to ensure symmetry. I'm sure some had a philosophy similar to what mine would have been: "good enough for the bottom of the ocean."

Of course, this handmade fishing gear has by no means disappeared from the modern economy. If you've ever driven around coastal Maine in the summertime, you will see just how excited people are about it. Coastal Route 1 wouldn't be the same without its "lobsters-on-everything" decorating scheme. If you were on a road trip and woke from a nap in the backseat,

Island kid Richard LeMoine Jr. standing in front of wooden lobster traps, 1954. *From the Christal Applin Collection.*

you'd know right away you were in Maine—even if the license plates on passing cars suggested otherwise. The roads are lined with antique stores, flea markets and miscellaneous piles of buoys.

Now, let me just say that I am a big fan of useless things that look nice. You can pick up some discarded fishing gear and instantly make your front yard, bathroom, garden or vehicle interior (go nuts!) look way more exciting. Who knows—you might even catch a lobster!

Unlike the decorating world, the fishing world has moved from wooden to metal lobster traps. Put one of these newfangled babies next to your begonias in an inland town and your neighbors will think you're dealing with a serious raccoon invasion. Wire traps do have many advantages over their stylish predecessors. For one thing, they require much less repair. Wire traps generally stay in good shape over a minimum of five years and can be patched up for ten or more years. They can hold up to rough seas that would dash wooden traps on shore. Wooden traps also have to be taken up periodically to avoid waterlogging; a heavier trap is harder to haul. As an added bonus, they come in all sorts of different colors—as opposed to just "wood."

Donnie Carlson has been in the trap-building business on Swan's Island since 1984. He described the gradual shift to metal traps around the 1980s:

> *I think that for some reason, the wire trap seems to fish better. I remember when I was fishing with my father that that seemed to be the thing that really changed people over. I don't know whether there was smell to the wooden traps that wasn't to the wire—I don't know what it was—but they did seem to fish better.*

Donnie builds traps to the specifications of each customer. "Everybody has their different styles, shall we say," he laughed. People request whatever features they think will fish better. Some haul from different sides, some have extra vents and some favor different heights and widths.

"There are fishermen that believe color makes a difference," Donnie said. "Black and green were the original colors, and through the years they come up with different colors. It went from green and black to red for a while, then it went to yellow, then white and I've seen purples and grays and blues."

Donnie comes from a family of fishermen and grew up helping build wooden traps. "I was a sternman with my father for a while before we had wire traps. I can remember as a kid going into the woods and cutting off tree limbs and bending them, making parts of the trap there. He would go

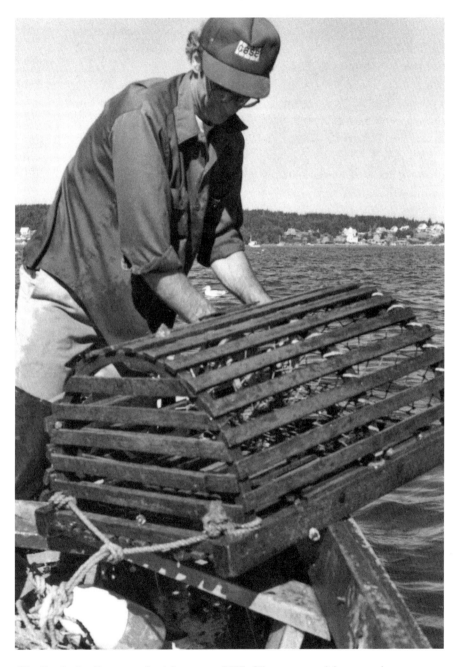

Clint Staples hauling a wooden lobster trap, 1988. Clint was not a lobsterman but was hauling his mother Melita's traps. *From the Gwen May Collection.*

up in the tree and cut them down, and my job was to trim off the ends and gather them up.

"I can remember when he would build the bottom of the trap they would put cement into it for ballast. I would help him with that. We'd have all the bottoms kind of spread out on the lawn out back here, and he would be mixing cement and I'd be taking a can full and dumping it in. We'd put the initials in eventually and the numbers. It was quite an operation," Donnie remembered. "The shop next to me was where they all used to work. My grandfather and my father and my brother were all in the business, and I would help."

A lot of women's work also went into the fishing business. Carolyn Martin is proof of that. She remembers the days when her mother helped build traps. "She worked right alongside my father," Carolyn said. "She'd go in the woods and help him get stuff and bring it out and saw it up, and she'd be in helping right along.

"I remember one time they stayed up all night because somebody wanted thirty-five traps the next day. It took 'em all day to get the stuff together and saw it out, so they stayed up all night. But they had the thirty-five traps the next day. Fifty cents a trap," she laughed. "That was ridiculous."

The materials were available if you were willing to put in the work. I asked Carolyn where they went to get branches for the traps. "You could go anywhere on the island, they didn't care," she said. "Long as you didn't cut the tree itself, they didn't care." She explained the process:

> Well, my father and Mertie Morrison ran a mill where they cut the logs. They cut the bottom parts and the laths. And then you had to go get spruce boughs a certain length—I can't remember how many feet now—and you had to steam them and bend them over to make the round trap.
>
> You'd take one end in the trap and take the other foot and hold that down and start, you know, bending from right there. You keep bending just a little bit so as not to break 'em. And then we had a pole. We just slid that on over and started lathing them up. I've built a good many traps. And it was fun.

The hands-on work created some fond memories. "One time my father got up a spruce tree," Carolyn told me. "It was a real tall one and had some beautiful boughs in it. He got up there, and something tapped him on the shoulder. And he says, 'Augh!' I said, 'What's wrong?' He says, 'Bring me up a rope.' I said, 'Uh oh, what has he done?' There was an arctic owl dead on the branch in perfect condition. So he lowered it down to the ground and

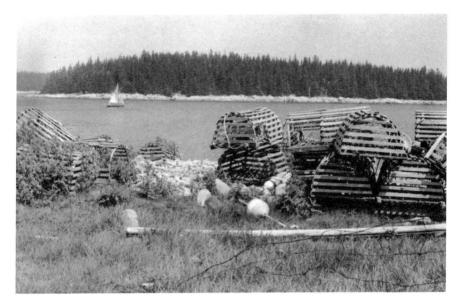

Austin Sprague's wooden lobster traps on the shore, 1963. *From the Elizabeth Mills Collection.*

had it stuffed. But that had knocked over a bit and hit him on the shoulder and scared him—he almost fell out of the tree!"

I asked Carolyn, now in her mid-seventies, about shimmying up trees to cut branches. "Oh, I didn't mind," she laughed. "But today you wouldn't get me doing it!"

The changes in fishing gear over just a few generations are pretty remarkable. There was a certain degree of camaraderie and fun in the old way—families pitched in. Even the extra repair time needed with wooden buoys meant there were more people around on the wharves, chatting and working. But so it goes. You'd get more family bonding time traveling by horse and buggy, but people won't be tossing out their car keys anytime soon. Though a carriage would look great in my living room…

KNITTING FOR FISH AND FRIENDSHIP

This is the story of how I became a knitter and made friends on Swan's Island. As you might be able to guess from the fact that those stories are one and the same, I am not the island cool kid. There was a point when I first moved here when I could have made an effort to reach out to people my own age. I was either too nervous or happy enough in my own company. The people I got to know first were those I met doing historical work—not exactly spring chickens. As a result, I have a wonderful group of pals who could theoretically be my parents and even more who could be my grandparents. I have a nice head start on most of my mainland peers; I've got plenty of advice stored up for future dealings with marriage, divorce, menopause, widowhood and keeping quiet when you see your daughter-in-law raising your grandkids the wrong way.

The summer before I moved to Swan's Island, friends of mine joked about the prospect of me losing all my social skills after two years of island life. Alone on a rock in the ocean with only a cat as a companion, I would develop strange new habits. That didn't end up happening—if only because my landlord doesn't allow cats.

I've since learned that island life can make you more sociable, not less. People get to know you just because you're there. In a smaller community, it's harder to isolate yourself within a group of people similar to yourself. There are great friendships among islanders of vastly different ages, beliefs and backgrounds. It's normal out here. You make friends with the people around you.

Alberta Sprague Buswell (1910–2009) knitting a sweater circa 2003. *Photograph by Ann Marie Maguire, from the Albert Buswell Collection.*

My first social interactions were with the groups where I knew I'd be welcomed: senior walking group and Tuesday night knitting. Yep, pretty wild! Picture the scene: It's February on Swan's Island. Some of the fishing families have run off to vacation in climates that don't make your nose hairs freeze. You've eked another meal out of the grocery run you made four

weeks ago. Your house looks like the sort of place that doesn't get visitors on a regular basis, or at least not visitors you're trying to impress. But it's Tuesday, so you bundle up and head out to knitting.

Cheri Ellison is our hostess, clearly born to fill this role. Her home is immaculate. There are snacks. The variety and caliber of her porcelain cups would make a six-year-old tea party guest faint. She presides at the head of the table and divides her time between conversation and "hotting up" our cups of tea so diligently that I'm not sure I've ever actually seen her knit. Her co-leader, the opposing force at the other end of the table, is Suzette Wheaton. Suzette is a ball of energy, knits up a storm and is always ready to shock us with her latest method of killing mice. She claimed me as her knitting pupil and loudly shooed off all Cheri's attempts at instruction.

Their methods are unique. Suzette cranks out socks and mittens as though her fingers had built-in knitting needle attachments. Cheri rips out the same scarf three times until it's perfect. Suzette sells her goods at rock-bottom prices at her roadside vegetable stand. Cheri buys the finest yarn and gives everything away. Suzette taught me a fisherman's knot to use when joining yarn. Cheri would sooner die than use a knot in her sweater.

Of course, the act of knitting is the least important part of knitting group. Tuesday nights are our time to get together, enjoy a little break from the daily routine and, of course, share all the latest gossip. There's often a broad range of ages and a good mix of native islanders and transplants. The knitters change from week to week, but the tradition continues.

There's a long history of knitting out here, due both to people's reliance on handmade goods and the needs of a fishing community. Some knitters were locally famous for their productivity and skill. Alberta Buswell was one such knitter. Two of her five children, Theo Buswell May and Albert Buswell, shared stories of Alberta during interviews with Meghan Vigeant.

"My mother, she had many, many talents of sewing and knitting," Albert said. "Especially knitting sweaters. She used to make 'em, you know, and sell them. And she would knit stockings and just about everything—magnificent quilts, patchwork quilts and so forth. She was quite proud of that. She also did something, I think they called it tatting, where they make these fancy doilies and things."

Theo remembers her mother's work well. "You couldn't get the quilts that my mother had made in one room, I know," she laughed. "Every grandchild has got one. And they've got a sweater from my mother. Everybody that had a baby always got something. Oh, she knit up a storm. She was knitting the

An island lady doing her knitting and enjoying the outdoors. *From the Gwen May Collection.*

summer before she died. Her hands were knotted up with arthritis, but she could still feel her fingers. She was ninety-eight years old."

"She always had to be doing something," Albert said. "She couldn't sit still. And for many, many years after my father stopped lobstering, they would knit the bait bags that the fishermen would use, you know, and the heads that go into the lobster traps knit out of nylon twine."

"Alberta would knit all my heads," lobsterman Spencer Joyce remembers. "She would do a ball of twine for about six dollars. It's unbelievable...that woman used to knit all the time. I don't know how she'd do it. Her hands would be all sore, and she'd have white athletic tape on her fingers where she hauled."

Alberta passed her skills on to her daughters. Theo May knitted bait bags for many years. Bait bags are more or less what they sound like—mesh bags that hold bait. Each lobster trap gets a full bag before it's dropped in the water. The knitted twine pattern leaves holes so that the dead fish inside can work their magic on lobster appetites.

Theo and lobsterman Joe Staples led a workshop at the library last winter for anyone who wanted to learn the dying art. Joe was accompanied by his grandsons, Marshall and Shepard, who gave remedial lessons to anyone who needed them. I sure did. Given the number of people who showed up excited to learn at those workshops, knitting bait bags might not prove to be a dying art after all.

The process takes a lot of practice to master. It's not done like regular knitting—even the tools are different. "Well, you've got a needle and what they call a mash [mesh] board," Theo said. "You have to take it up on a ring and knit the bag down and then close it off. Then you take bigger stuff in the other end of the bag and go around and pucker it up so that that bottom part is what opens up. You put your bait in and then pull it up tight to tie it on your trap."

Island knitting crosses the gender divide as well as the generational. Fishermen mastered the skill to make and repair their equipment. Sailors also knitted as a way to productively pass time on long voyages.

Johnny Wheaton's grandfather, who was born in Nova Scotia, came to Swan's Island around 1917. He was unable to fish after losing a leg in a trawl-fishing accident. "What he did after was sit and knit heads, pockets, big trawls," Johnny said. "Now in the summertime, 'course, he would work on the fish wharves—splitting fish, shacking fish and stuff like that."

Theo explained what heads are used for: "You see that trap out there, you see that orange part inside? That's the head. That's where the lobsters go

inside, right there. There's a hole that they go up inside, and then they fall down into the trap."

More recently, heads became available for purchase in a pre-knitted roll. "It's probably been, I'm guessing maybe ten years since these started to come in," lobster trap builder Donnie Carlson said of the new heads. "About the time, fortunately, that the head knitters who were knitting for me were getting old in age anyway. There are still some fishermen that would like to have those type of heads, but there's nobody on the island that will do it professionally."

Donnie remembers the knitters well. "Usually it was a visit," he explained. "You would go in to get the heads but you couldn't just walk out. You'd have to talk and sometimes have a cup of tea or a piece of pie, something like that. So it was definitely a very social type of thing. I enjoyed talking with the older people."

We Tuesday knitters are hardly on the same scale as the professionals of old. A few of us sell our products at local craft fairs, but as far as I know, none of our work has been directly responsible for catching a crustacean. What does remain the same is the heart of it: the stories and the support. And sometimes that's just what you need.

31

WE STAY FOR THE HISTORY

I'd like to warn people about the potential dangers of studying history. I'm talking worse than paper cuts, eyestrain and not fitting in well at parties. We are all shaped more than we realize by the past—events that happened long before we were even twinkles in our parents' eyes. Once you start thinking about how things got to be the way they are, it's hard to know when to stop.

Countless tiny events accumulated to create the world around us—what we say and do and eat and believe. Somewhere, sometime, somebody wore the first ever pair of pants. It took generations to determine that eating lobsters makes you fancy and eating worms makes your fifth grade classmates freak out. Things develop slowly but surely.

In small communities, you run into people with long memories. They know how certain things came to be or can at least make up pretty convincing reasons. History remains a part of the present experience. Of course, you find this in cities as well, but with the constant shifting of characters, it can be harder to hold on to that shared past.

I wondered about that when I moved to Swan's Island. A lot of people who live here have been around one another since birth. How do you live with so much accumulated history? How do you distinguish the person giving you tax advice from the kid who threw up in your parents' backseat forty years ago? All of those stories and connections layer up and form the backdrop of daily life. You look at a new store and remember the school that was there. The vacant lot still reminds you of the playground where you broke your wrist in a game of tag.

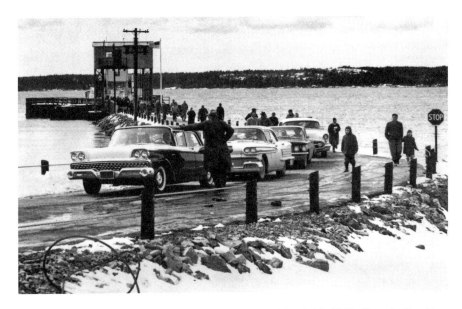

The arrival of the first ferry, the *William S. Silsby*, on March 13, 1960. *From the Donald Carlson Collection.*

I can see how it could be tough to get along with everyone in a place like Swan's Island. Hard to escape from a reputation. Imagine living in a community where at age seventy you still have to deal with the nickname you earned in middle school. We all have periods we'd rather people forgot, but that's the price you pay for keeping the good memories. And after all, when it comes to long memories, Swan's Island has nothing on some other parts of the world.

I spent the summer of 2009 living on the western coast of Scotland. I received a scholarship to work on family farms and "research local traditions," which meant I could go to dances, read wonderful folk tales, wander and chat with folks. I first arrived in the eastern part of Scotland, closer to England in distance and culture. When people heard where I was going, a few of them warned me about the west. "Watch out for people in the Highlands," I was told. "They're weird, religious and make eye contact with strangers."

That summer was probably the best preparation for Swan's Island that I could get. If I bumped into an old woman on a walk, within a few minutes we'd have covered my marital status, home life growing up and the professional standing of the family I was staying with. One lady I met on a

hillside brought me along to a church service conducted entirely in Scots Gaelic—complete with bagpipes. I was in heaven.

The old-timers I ran into there sure knew their history. I spent a month on the Isle of Mull—a beautiful granite and peat-covered island dotted with the remains of abandoned stone villages and churches. Many tenants were forced from their homes in the "Clearances," a period when the large landowners, or "lairds," realized sheep were more profitable than small family farms.

Prior to that, the population dropped when the island's young men followed their clans to the Battle of Culloden during the Jacobite Rising. I was warned to watch out for the Campbells—back then they'd fought on the wrong side. I should just point out that the Battle of Culloden took place in 1746. To get a little perspective, that's a full three decades before the American Revolution. Being warned about the Campbells is roughly equivalent to an American saying, "Gosh, I'd love to go get ice cream with you, but I heard your family members were Loyalists." Of course, people had a sense of humor about it. But it's fascinating how active a presence the past can have in daily consciousness.

Living with our history does not always divide us into factions; it can also provide the foundation of our identity and everything that makes a place important to us. Life on a Maine island is not always easy. There are more convenient places to live if you want a nice view and access to fishing grounds. We stay here for the people, the memories and the stories. Whether we realize it, we stay for the history.

That being said, I've learned one lesson out here that I feel duty-bound to pass on. It goes as follows: do not date a historian unless you are prepared for the consequences.

My fellowship advisor, town clerk and pal Gwen May is the source of this lesson. She's lived on Swan's Island her whole life apart from a stint on Matinicus. In her teenage years, Gwen had a cute ponytail and a fun-loving spirit. Like many kids, Gwen found true love a couple times before she was old enough to get a driver's license.

At twelve, she was "engaged" to Normie Burns, famous (though perhaps not at that age) for his resemblance to Elvis. He gave Gwen a twenty-five-cent diamond ring and had his mother in tears before someone pointed out to her that the kids probably weren't going to go through with it.

By age fifteen, Gwen had moved on. Her current beau was Lawrence "Cappy" Carter, who came to the island in his early teens. They dated for a couple years on and off. "Mostly on," Gwen told me. "He was a romantic,"

Lawrence "Cappy" Carter in a photograph he sent to his sweetheart, Gwen May, circa 1963. *From the Gwen May Collection.*

she laughed, remembering the love letters he sent her while he spent time in Florida. Some included snapshots of him leaning on cars, playing the guitar and grinning. "So I could drool," Gwen said.

It was not meant to be. The couple parted ways, though they kept in touch in later years and are now old pals. Cappy lives in Ellsworth and occasionally visits the island. Gwen and Cappy were recently reminiscing about the old days when Gwen, who always loves a good laugh, brought up the time that Cappy dumped her. Cappy denied everything—he was sure he never did such a thing. He had been in love!

Gwen May, historian to the core, went to her attic and brought out the fat envelope labeled "Cappy's Junk" that she had kept since age fifteen. She sifted through the letters—there were about fifty in all—until she found

"The One," the Dear John letter that ended it all. It was still in its envelope, stamped 1963.

Always ready to make a sacrifice in the name of history, Gwen let me scan the letter to add to our historical collection, along with a photograph of the ring Cappy gave her. It was a worn circle with three hearts and the message "Going Steady." The letter itself is fantastic. Anyone who has ever been dumped will shudder at the opening lines: "Dear Gwen, This is the letter that I owe you. It is, without a doubt, the most difficult letter that I have ever written."

Cappy goes on to explain that he has unexpectedly started to "like another girl very much," and since he promised to never go out with anyone else as long as he and Gwen were going steady, he needed to make a clean break. The letter was sweet and thoughtful enough that he didn't even give her the comfort of being able to hate his guts. Poor Gwen!

She got some small revenge, though, when she could produce the letter almost five decades later. Gwen described Cappy's reaction. "He said, 'At least I let you know before I started dating another girl.'" Gwen laughed, "Yeah, right." There's nothing like documentary evidence to gain a point and solidify an old friendship.

Perhaps island life is a good treatment for heartache. Nothing takes the drama out of a relationship like seeing the other person buying milk and mowing their lawn and driving to work. With so many tangled webs, at a certain point you end up just letting go. Maybe that's the origin of the wonderful sense of humor I've found out here. When your ex-girlfriend of fifty years hands you the original copy of your breakup letter, what can you do but laugh? It might be the only cure for history.

CONCLUSION

Looking back at two years as a resident of Swan's Island, it's hard to summarize this place. Each passing month has introduced me to a new person, given me some new insight into how this place ticks. It would take a lifetime, let alone a couple years, to make headway on that one.

Most of my friends left school for more urban destinations—not that that's saying much. But it does make a person think about finding a home on a rock in the sea where the store closes two hours before your workday ends and everyone knows what you're up to, little as that may be. In my case, I admit it's been self-serving. I have had the thrill of being universally recognized and all the benefits that come with life in a semi-isolated place. I was allowed to run rampant over a historical society, teach, sing and lead (you can see how the power's gone to my head). If I were doing the same work in Boston, no one would give a rat's patoot. In a small place like this, people notice.

I know I'll never quite fit in here, not even if I finally get rid of my New York license plates, fake a Maine accent and go around cooing, "T'nt it cunnin'?" at babies (which translates to something positive). But somehow this has been the best place to be a newcomer. I've been chatted to, given food, shoveled out of snow banks and even speculated over for my potential contribution to the gene pool. People have made me feel like I'm a part of it all, and I can't say how huge that is.

Of course, there are tensions; people do the same dumb things here that they do everywhere. The *Captain Henry Lee* ferryboat, moving people from

Awash, by John Bischof. *From John Bischof, Swan's Island Educational Society Collection.*

the mainland to the island, isn't a portal into a more wholesome world. It's not even a portal into the last century. But the thing is, as an individual, you matter out here. Your life bumps into all these other lives, for better or worse. I think on the whole it encourages the kindness, goodness and humor that I've constantly seen.

This is going to sound awful, but when I think of my connection to Swan's Island, I think of the funerals and memorial services I've attended. More than I'd like in two short years. Even so, each one is a window into the heart of the island. People stand and tell these wonderful stories about the people whose lives touched theirs. It is joyful and heartbreaking. People remember you here because they knew you. They saw you at your best and worst moments—probably even *caused* your best and worst moments.

I was part of one service in the fall of 2012. Neil Fredette wasn't a native islander, but he chose to make his home here after being diagnosed with cancer. I met him at the Sunday night hymn sing. When he learned that I played the trumpet, he immediately offered me his own—said he couldn't play it anymore and would like to see it get some use. He handed it over in a characteristic island way: leaving it in his unlocked car in line at the ferry terminal for me to pick up the next time I passed by.

I didn't know the extent of the sickness that made Neil unable to blow that horn. My family met him that August, and I was excited to introduce them to the guy who'd been so nice. I'd been playing the same trumpet that my

brother and father had used before me, so Neil's was a welcome addition to the family. We had a nice chat outside Les Ranquist's wharf. Neil was calm and happy. In October, I picked up that trumpet to play "Amazing Grace" at his memorial service, crowded with friends and family. It was proof that you don't have to be born on the island to have it become a part of you. I didn't know Neil outside of a few chats, but he was an islander. Generous from the start.

That's the one thing I've heard from the people I've interviewed, again and again. "They were there for me. They looked out for me. They saw me through it." It's never just one or two people—the relative, the close friend—it's "they." It's the woman who comes to the benefit potluck and donates ten dollars that mean more to her than one thousand would to other people. It's the EMT who gives up so much time to ensure that when that one accident happens, it won't become a tragedy. It's the countless folks who would give you the shirt off their backs without question.

The history of Swan's Island is not bound up in town records from the 1900s. It's alive in the memories of everyone who has set foot out here—last week's frozen pipes, the time your parents got lost in the fog, the way your neighbor's dog used to smile at people as a party trick. I'm glad I had the chance to become a part of these stories. I will carry the mark of this place for a long time, as sure as my pants will carry the mud of the island clam flats and my fleece jacket will never quite stop smelling like lobster bait. Some things leave a stain you can't ever remove, and I am so grateful for that.

Thank you to all who shared your lives with me—you will not be forgotten.

BIBLIOGRAPHY

Bernstorff, Elof. "Swan's Island Woman Recalls Days of Shipwrecks." Swan's Island Historical Society, n.d.

Buswell, Albert. "Death By Drowning: A Fact of Life On a Maine Coastal Island." Swan's Island Historical Society, n.d.

Gill, N.S. "Book III.6 of *The Odes and Carmen Saeculare* of Horace." *Ancient & Classical History*. About.com. http://ancienthistory.about.com/od/Horace_Odes/a/Book-III-6-Of-The-Odes-And-Carmen-Saeculare-Of-Horace.htm (accessed January 27, 2014).

MacKay, Gordon. "Maine Coon-tail Cats, Swan's Island, Marie Antoinette." *Island Advantages*. Swan's Island Historical Society, n.d.

Maine Historical Society. "1850–1870 The Civil War." Maine History Online. http://www.mainehistory.org/programs_cw.shtml (accessed January 27, 2014).

Monroe, Judith. *Peripheral Visions*. Swan's Island, ME: Crone's Own Press, 1992.

Pullman, Philip. "After Nourishment, Shelter and Companionship, Stories Are the Thing We Need Most in the World." *Goodreads*. http://www.goodreads.com/quotes/35497-after-nourishment-shelter-and-companionship-stories-are-the-thing-we (accessed January 27, 2014).

Small, H.W. *History of Swan's Island, Maine.* Rockport, ME: Picton Press, 2001.

Vigeant, Meghan. *Guts, Feathers and All: Stories of Hard Work and Good Times.* Rockland, ME: Island Institute, 2011.

Westbrook, Perry D. *Biography of an Island: The Story of a Maine Island, Its People and Their Unique Way of Life.* South Brunswick, ME: Thomas Yoseloff Ltd., 1958.

ARCHIVAL MATERIALS

Friends of the Swan's Island Lighthouse
Maine Historical Society, Portland, Maine
Peary-MacMillan Arctic Museum, Bowdoin College, Brunswick, Maine
Penobscot Marine Museum, Searsport, Maine
Swan's Island Educational Society, Swan's Island, Maine
U.S. National Archives and Records Administration

ABOUT THE AUTHOR

Kate Webber earned a degree in anthropology from Bates College, with concentrations in "environment, place and history" and "medieval worlds." Kate worked with the Freeport Historical Society before spending two years with the Swan's Island Historical Society through the Island Institute's fellow program. Her varied historical work and social life on the island led to a column in the *Working Waterfront* publication, which formed the basis for this book. Kate has since moved to Portland, Maine, and is working for the Maine Humanities Council.